the design aglow
posing guide for
family portrait photography

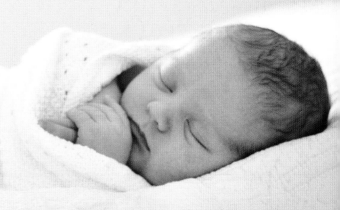

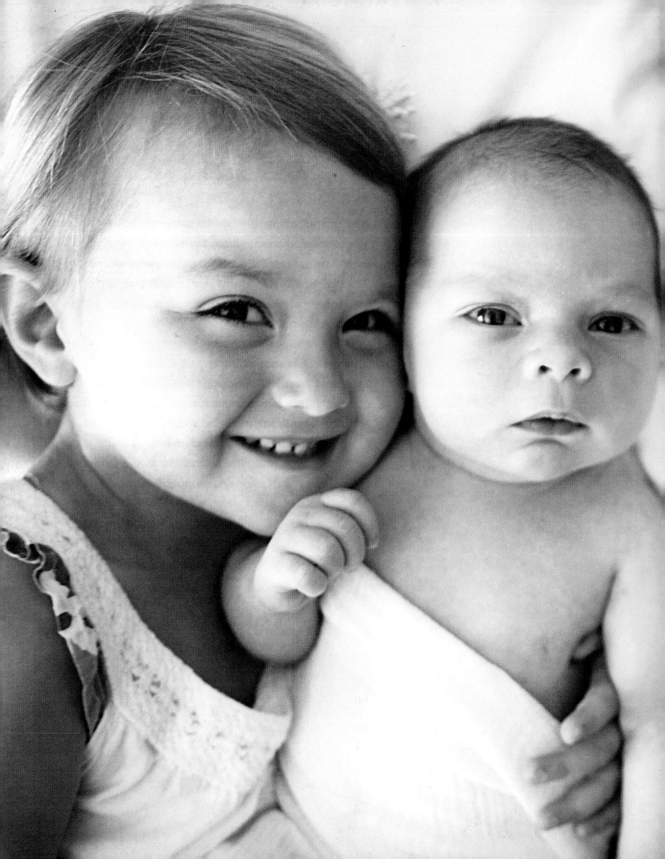

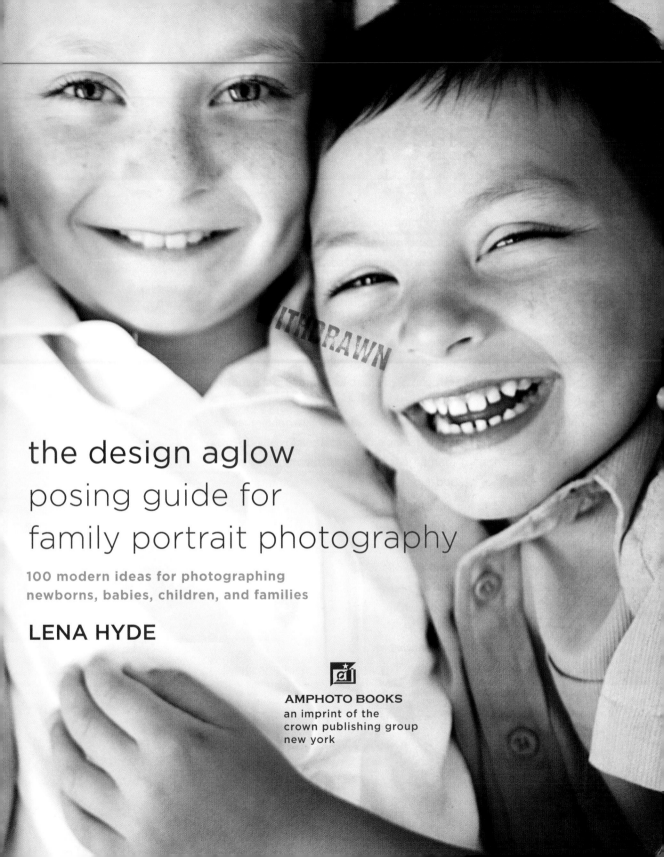

the design aglow
posing guide for
family portrait photography

**100 modern ideas for photographing
newborns, babies, children, and families**

LENA HYDE

AMPHOTO BOOKS
an imprint of the
crown publishing group
new york

Photograph on page 1 by Lena Hyde Photography
Photograph on page 2 by Tara Whitney
Photograph on page 4 by Michelle Huesgen,
 Untamed Heart Photography
Photograph on page 6 by Paul Johnson
 Photography

Published in the United States by Amphoto Books,
an imprint of the Crown Publishing Group,
a division of Random House, Inc., New York.
www.crownpublishing.com
www.amphotobooks.com

AMPHOTO BOOKS and the Amphoto Books
logo are trademarks of Random House, Inc.

Library of Congress Cataloging-in-Publication Data

Hyde, Lena.
The Design Aglow posing guide to family portrait
photography : 100 modern posing ideas for
photographing newborns, babies, children, and
families / Lena Hyde.
pages cm
Includes index.
 1. Portrait photography--Posing. I. Title. II. Title:
 Posing guide to
family portrait photography.
TR577.H93 2013
778.9'2--dc23 2012035838

ISBN 978-0-385-34480-7 (trade pbk.)
ISBN 978-0-385-34481-4 (e-book)

Printed in China

Design by La Tricia Watford

10 9 8 7 6 5 4 3 2 1

First Edition

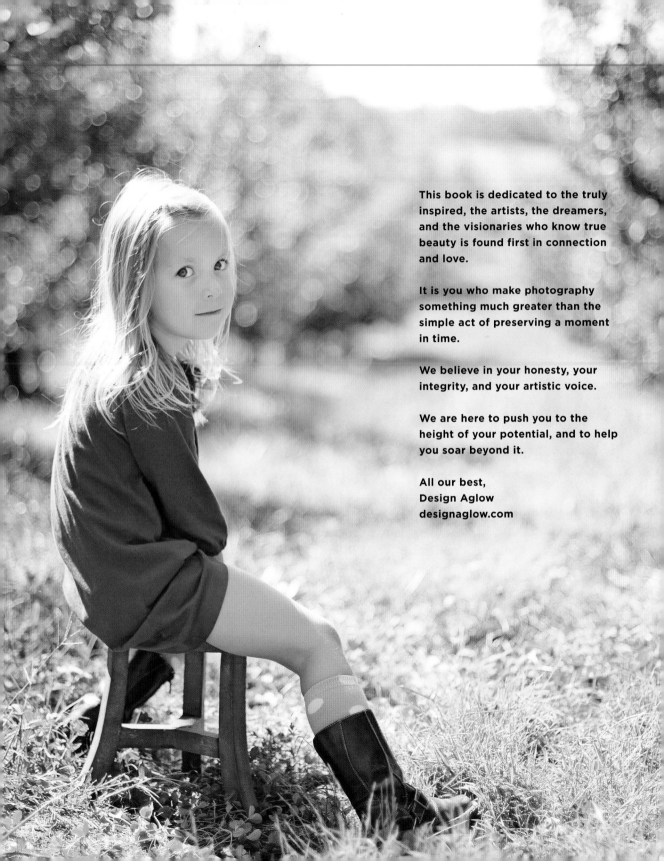

This book is dedicated to the truly inspired, the artists, the dreamers, and the visionaries who know true beauty is found first in connection and love.

It is you who make photography something much greater than the simple act of preserving a moment in time.

We believe in your honesty, your integrity, and your artistic voice.

We are here to push you to the height of your potential, and to help you soar beyond it.

All our best,
Design Aglow
designaglow.com

contents

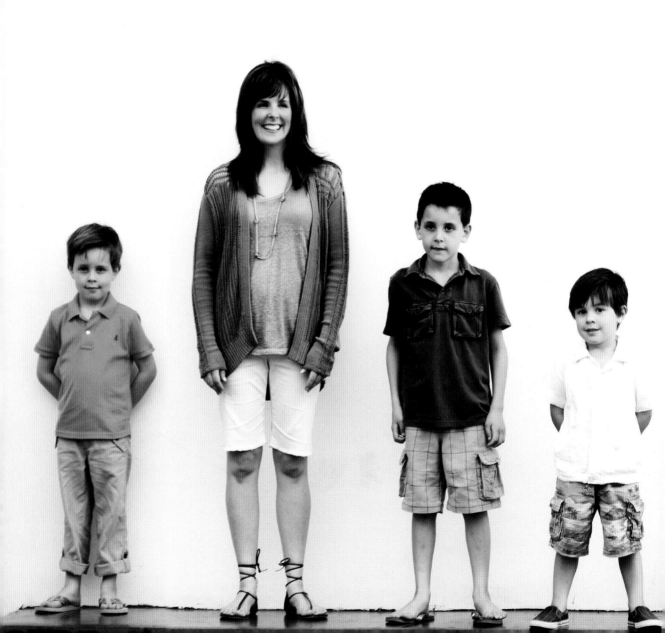

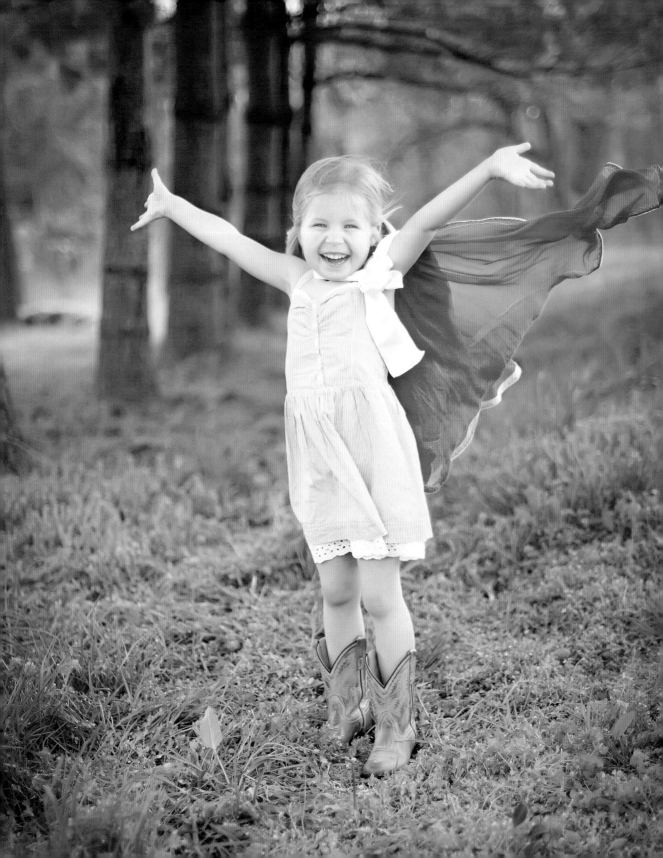

introduction

At Design Aglow, we have dedicated ourselves to flawless presentation, maximum efficiency, and professional success in a visually beautiful format for the last half-decade. Our goals: to enhance your photography, to save you time, and to help you increase your sales.

Based on our popular "InspireMe" Portrait Posing Guides, this book of stunning portraits features four in-depth chapters that share innovative and inspiring posing concepts for photographing babies, children, siblings, and families at their best. In each section you will also find posing tips, helpful lighting information, important technical facts, and added portrait ideas from the best photographers in the industry—all presented in a conversational, light tone.

Use this beautiful book in two ways: first, as an easy-to-transport visual guide for photography inspiration at sessions; second, in the studio or at home as a study guide of the techniques we employ for innovative portrait photography.

> **"Life itself is the most wonderful fairy tale."**
> —*Hans Christian Andersen*

By following the techniques and tips covered here, you will soon discover how to add emotions, texture, and color to your portraits, leading to beautiful results you will enjoy right away.

We invite you to explore, to expand your creativity, and, most of all, to become inspired by the wide range of innovative ideas we are about to share with you.

Come create fresh, modern, and extraordinary portraiture with us.

DESIGN AGLOW
Photo by Michelle Huesgen,
Untamed Heart Photography

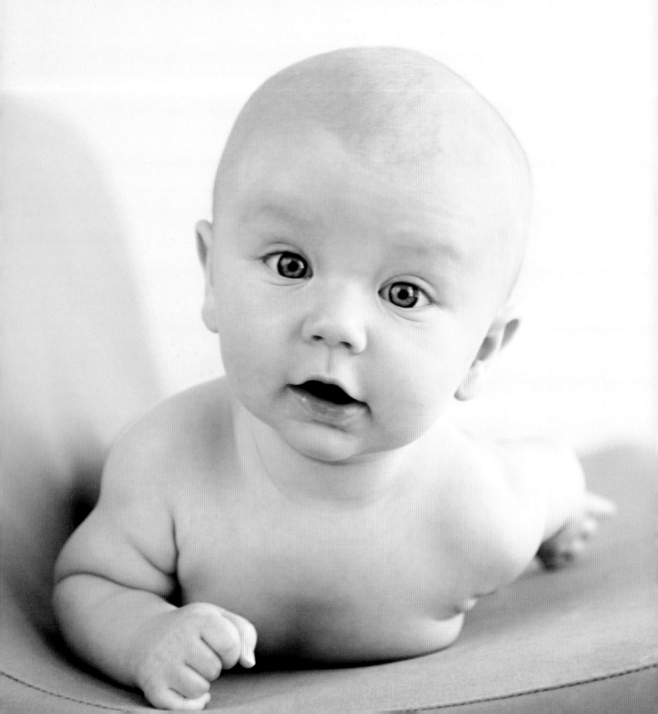

newborns
& babies

It might seem that babies and infants have less to offer in terms of poses, but in fact they offer a world of amazing possibilities.

With babies, we photographers become foragers for ideas, props, and scenarios that showcase the personalities of those young models. At the same time, they also allow us to express our own artistic vision.

Because working with the very young brings unique opportunities and challenges, thankfully there are some basic ideas you can keep in mind when photographing your youngest subjects. A shallow depth of field emphasizes the baby and accentuates brilliant pops of color in dazzling blue eyes or the sweet details on a tiny shoe. Black and white more so than color de-emphasizes noise in low-contrast lighting. A warm room at 80°F helps calm a sleepy newborn. Keeping a parent spotter nearby is always important, especially when you never know if the baby might risk falling. Encourage family participation in sessions; even when mom doesn't want to be the center of attention, a sweet over-the-shoulder shot (or even a capture of baby's hands in her hands) creates an important bonding and connectedness necessary for family portraits.

Now is the time to capture huge, gaping grins, shy smiles, and even the furrowed brow of a baby about to cry for lunch. Whether you have your subject posed in the comforting arms of a parent, in a modern porcelain sink, or au natural on an ottoman, documenting these all-too-fleeting moments creates precious portraiture to be treasured forever.

Photo by Lena Hyde Photography

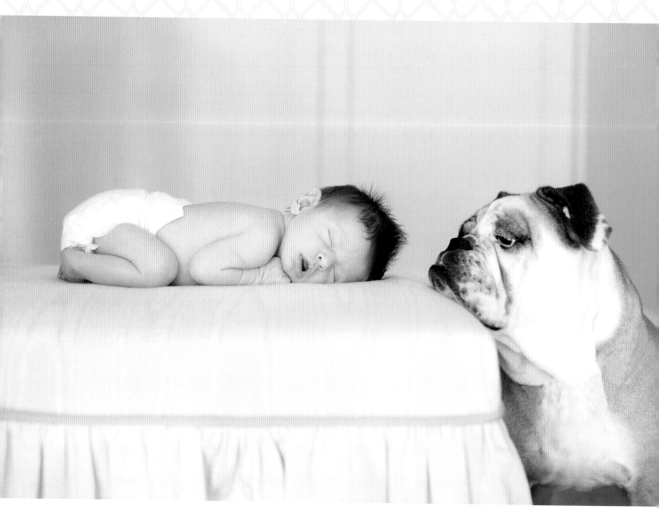

 In this bright room, sunlight flows in from behind the photographer, lighting the faces of the baby and pooch.

85mm lens, f/2.8 for 1/200 sec., ISO 400

Photo by little nest portraits

divine canine

There is nothing sweeter than dogs and babies, both prone to slobbering. For many parents, a dog was their first "baby," so it makes sense to capture these two together after the baby arrives. If the dog is large, position the sleeping newborn on an ottoman at face level with the pooch, and then ask the parent to get the pup's attention off-camera. For a smaller, gentler canine, have the dog lay down first; then place the baby close to the dog's furry face.

tip Ask your clients to wear the dog out a bit before the session by walking or playing fetch. Canines tend to exude quite a bit of energy, especially when there is excitement afoot. Keep a few extra treats handy to hold the dog's interest during the shoot.

in the nap of luxury

Photographing babies in modern environments offers fresh takes on the more typical, pastel-themed nursery captures. Here, a brilliantly colored Swedish blanket pairs beautifully with a newborn slumbering peacefully in the scooped seat of an Eames chair. Learn the art of the tight swaddle; young babies love it, and so do their parents. In fact, tightly swaddling a newborn and helping her into a deep sleep is surprisingly easy (here, Vera was so comfy, she would gladly have stayed nestled for another hour).

Just be sure to always keep a spotter nearby and remove the newborn after the shot, in case she moves or startles. Vera's mother was spotting her only inches away for safety.

tip Baby acne kicks in at 2–3 weeks, so try to grab newborn shots before that phase begins to minimize the need for postproduction editing.

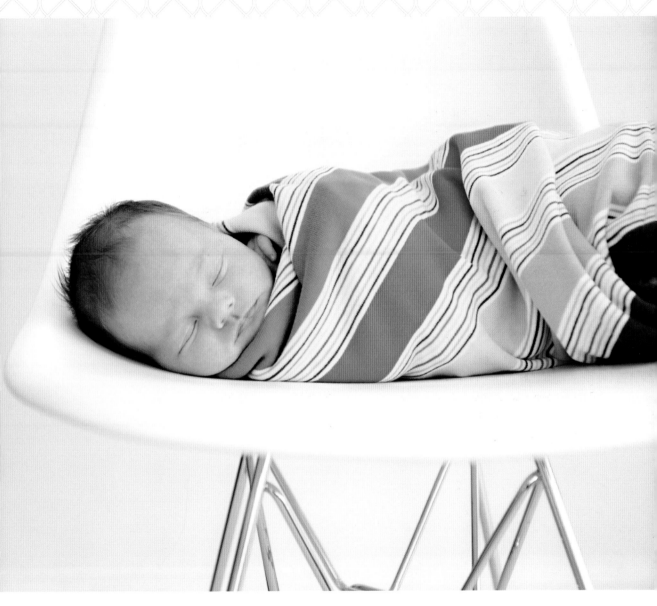

Natural light enters the room just left of the chair, with a small, 24-inch round reflector to the right of the chair gently directing light back onto the newborn's face.

28–70mm F2.8 lens, f/4 for 1/125 sec., ISO 200

Photo by Lena Hyde Photography

here's looking down
at you, kid

Always be aware of your surroundings during a session, so as not to miss the natural magic of unexpected camera angles and perspectives. In this case, dad is holding the baby in the way he is most comfortable for an adorable array of wide and tight shots. Note the family dog, who inspects the scene. This sweet shot from above results in an exciting, refreshing image, finer perhaps than any standard, straight-on capture. Height and safety play important roles, along with ensuring the baby and man's best friend are on good terms. An upstairs library loft provided the perfect perch. This sunny scene shows it is sometimes all right to look down on clients, photographically speaking.

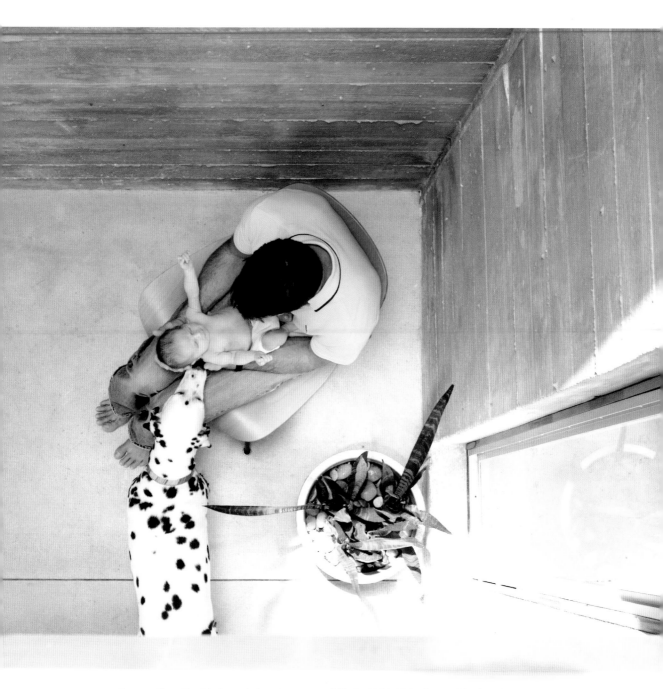

 Happily, this home's interior was well lit. Available light from a big glass door to dad's right bathes the scene in soft sunlight.

28–70mm F2.8 lens, f/4 for 1/160 sec., ISO 400

Photo by Lena Hyde Photography

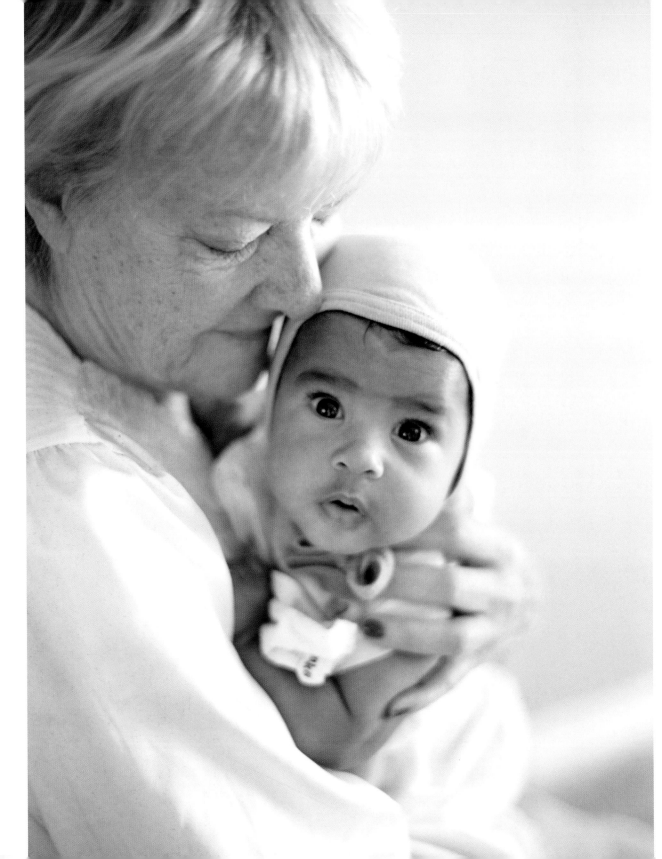

found moments

Sometimes, the best photographs come from simply being aware of the dynamics between your subjects and being open to unplanned moments. Here, during a camera break, grandma nuzzles her darling granddaughter. In an epiphany, the photographer picks up her camera to capture this ethereal, loving moment between generations. Providing optimal lighting and comfortable places of respite during session breaks encourages natural captures of quiet moments, since babies and nurturers are in their most relaxed and natural states. Black and white is a fantastic choice for blocking out colors that might detract from the scene, leaving the softness of the layers and allowing the focus to remain on this treasured moment and not on clothing or décor.

tip Casual, fuss-free dress is key to successful newborn photography. Advise your adult subjects to avoid wearing starched shirts or putting babies in grown-up styles, which can make them appear awkward and uncomfortable in photos.

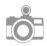

Gentle light from a nearby window creates delicate, beautiful highlights and soft shadows.
Contax 645 with 80mm Zeiss lens, Ilford XP film, f/2 for 1/60 sec., ISO 400
Photo by Elizabeth Messina Photography

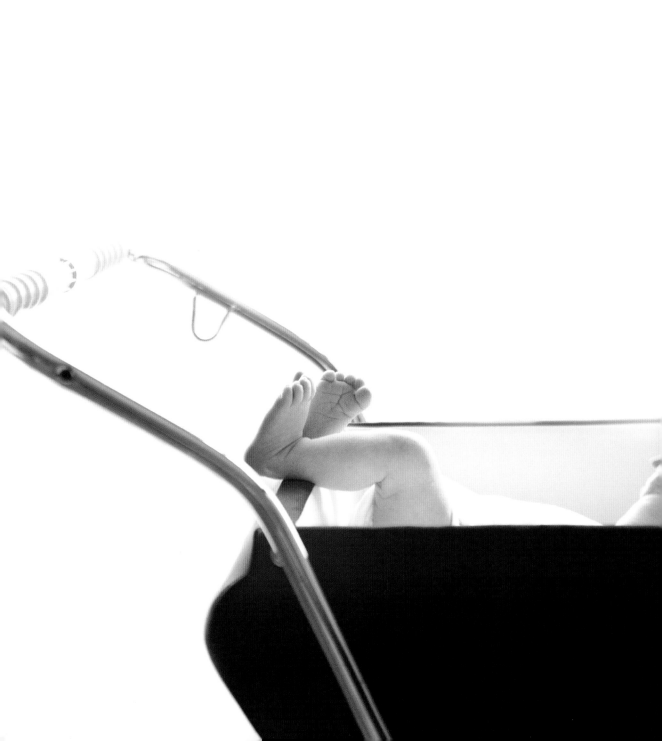

carriage capture

As a family documentarian, be sure to incorporate infant modes of transportation, whether a stroller, a carriage, or an antique pram. Not only will these wheeled vehicles provide quiet, comfortable moments for infants during sessions, but they will eventually prove interesting and retro, as in the case of this pram that the newborn's grandmother had used for the baby's father. Be wary of parts that could pinch tiny hands. Since this pram was used for naps and outings, the parents were confident with its safety. Try using a macro lens for tiny details like toes, fingers, belly buttons, and lips.

tip Because this pose shows only one little leg, it's a great one to use when a baby is fussy.

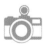

Light from a nearby bank of windows bounces off the room's white walls, creating a clean, white background and accentuating the child's toes and the pram.

24-70mm lens at 70mm, f/3.2 for 1/100 sec., ISO 1250

Photo by Anna Mayer

sweet
somethings

Whenever possible, capture emotion to create the most powerful imagery. There is plenty of love in this new family, and this photo will speak to the clients for years to come (as well as to the grown-up child, who can later fondly remember his parents in love). Grab a few pictures of just dad and the baby; then ask mom to come in for a group shot. After a few images, when the couple is relaxed and comfortable in front of the lens, ask for a slow, gentle kiss while dad is still holding the baby. This shot is especially delectable thanks to the white sofa and big paintings, though a plain white or softly colored wall will work equally well. The bright pillow balances the composition and adds a bit of interest.

tip Be sure to tightly swaddle a newborn baby and wait until he is sleeping soundly before moving him. Babies sleep most of the day during the first two weeks of life and don't mind being moved; after that, not so much.

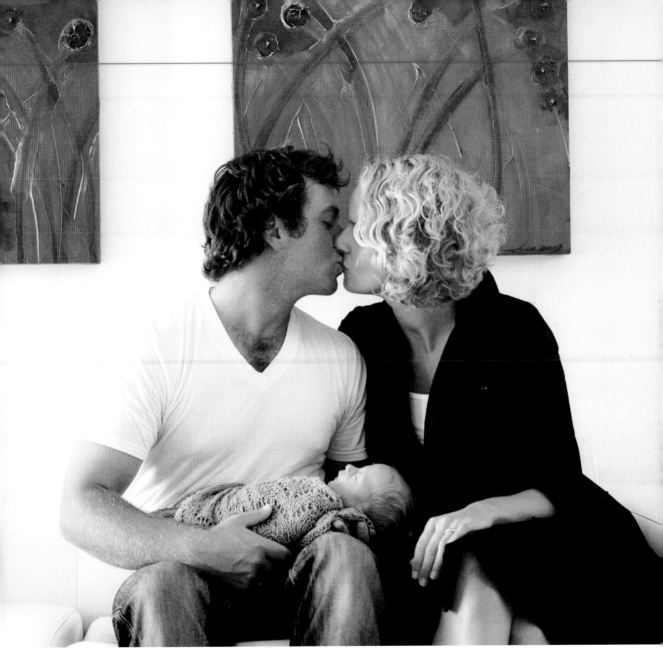

Light streams through a large set of windows to the left, washing over the family.
The all-white walls, floor, and ceiling reflect the less directional light everywhere.
70–200mm F2.8 lens, f/3.5 for 1/250 sec., ISO 200
Photo by Lena Hyde Photography

shelf life

This is a great pose when you're working with an older sibling who is not yet sure about holding her new baby sister or brother. Have the big sister (or brother) sit on a deep, wide bookcase with some personal belongings on display; then swaddle the baby and gently place him next to the older sibling, who can simply look at the new baby. The contrast between the siblings' sizes is delicious, as are the pops of color in the room and bookcase. For variety, grab separate portraits of each child, as well, starting with the baby and then handing him to mom while working with the older sibling. These images can also be taken on a wide bench if a stable shelf isn't available.

tip Never, ever place a baby on a ledge without a consenting parent in the room who agrees to spot the baby, even if the infant is just a few inches off of the ground. Have mom or dad close by, barely out of camera range, just in case.

Along with a bank of windows just to the left, a higher ISO ensures that this pretty-in-pink room swims with light.

28–70mm F2.8 lens, f/4 for 1/250 sec., ISO 800

Photo by Lena Hyde Photography

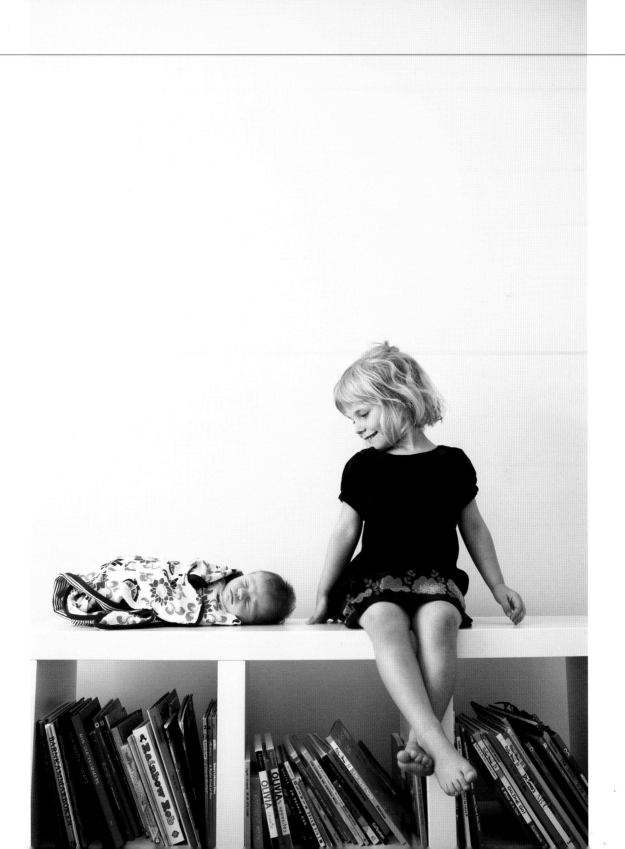

togetherness

This pose highlights a tender moment between a big sister and her new little sister. Start by settling the slumbering sweetheart on an ottoman; then ask the big sister to kneel and carefully rest her head on the baby's back. Try a shallow depth of field to make the background blurry. For a slightly different capture, grab a picture of the older sister's hands holding the newborn's hands and/or baby's little fingers wrapped around big-girl fingers.

tip New babies love warmth. To lower the risk of waking a baby when moving her to a new spot, use a heating pad (on low) to gently warm the spot first. A hair dryer also works well, and little ones don't seem to mind the white noise. In fact, a little white noise often helps lull a baby into sleep and covers up background sounds. If you don't have a hair dryer on hand, there's even a white noise app you can use.

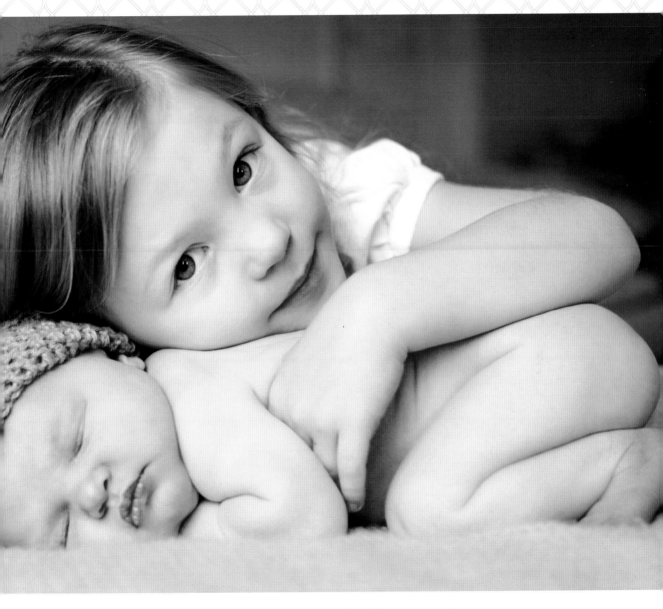

 The background in this well-lit picture was burned in postprocessing to draw the eye to the darling duo.

50mm F1.2 lens, f/4 for 1/200 sec., ISO 1250

Photo by Whitebox

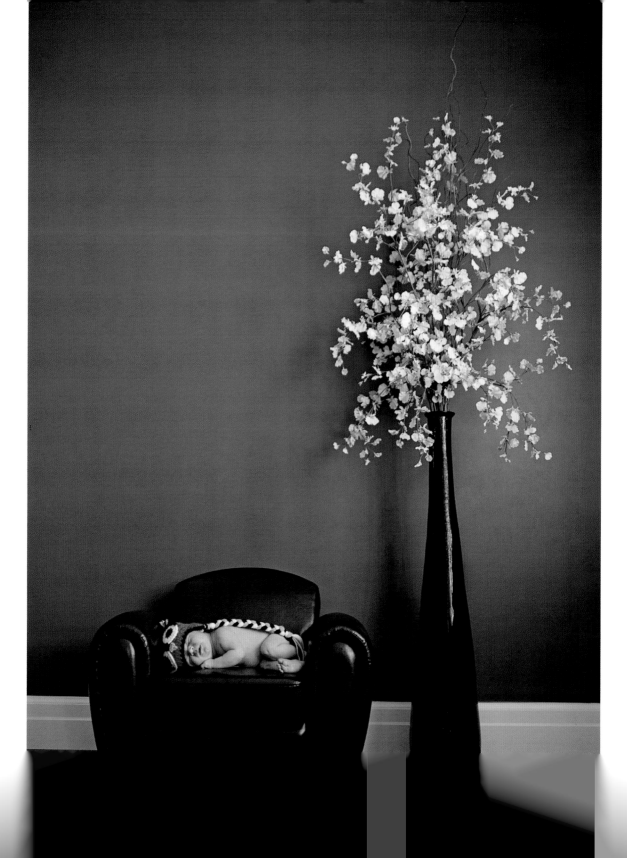

take a seat

Many clients want environmental portraits that include parts of their home. Be on the lookout for unique places for the baby, and don't be afraid to gather and rearrange items throughout the house (with permission, of course) for vignettes that show off your clients' decorating style. Here, a baby is couched in modern sensibility, with a smoky blue wall and various props—chair, vase, and flower—pulled together for a vignette. Against this clean backdrop, the little owl cap adds a hint of cute color to create a more youthful, soft portrait. The baby is too young to move around, but his dad stays close by outside of the shot for support. In colder months, a portable heater placed at a safe distance makes the chair (and room) more comfortable. For a second portrait from the same setup, have mom sit in the chair and hold the baby.

tip Due to still developing muscles, newborns tend to have crossed eyes. Sleeping shots are a safe bet for the most flattering images.

 Along with using an increased ISO, all window blinds were opened to grab as much light as possible.
24-70mm lens, f/2.8 for 1/80 sec., ISO 800
Photo by Sheryll Lynne Photographers

upwardly mobile

Framed by a fun and colorful mobile, this happy, entertained baby erupts in gorgeous grins. A clean, white Onesie lets the baby and mobile steal the scene. To capture this moment, stand on a sturdy ladder or step stool to shoot from above. (Always wear a camera neck strap, just in case your gear slips.)

For a second shot from this same setup, zoom in tightly on the baby's face without the mobile for an overhead close-up that will melt mom and dad's heart.

tip Images from a family's home environment are important. As the baby grows, he'll love looking back at the details of his nursery and the comfort of his first possessions.

 This dark room meant bumping up the ISO and using a large white reflector next to the crib to bounce scant window light back onto the baby's face.
24–70mm lens at 24mm, f/2.8 for 1/200 sec., ISO 1250
Photo by Anna Mayer

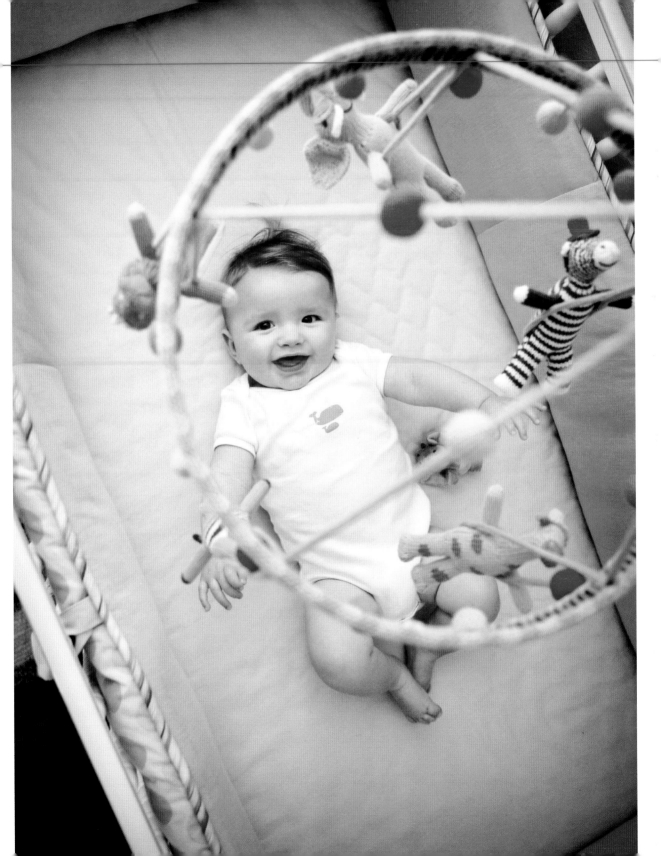

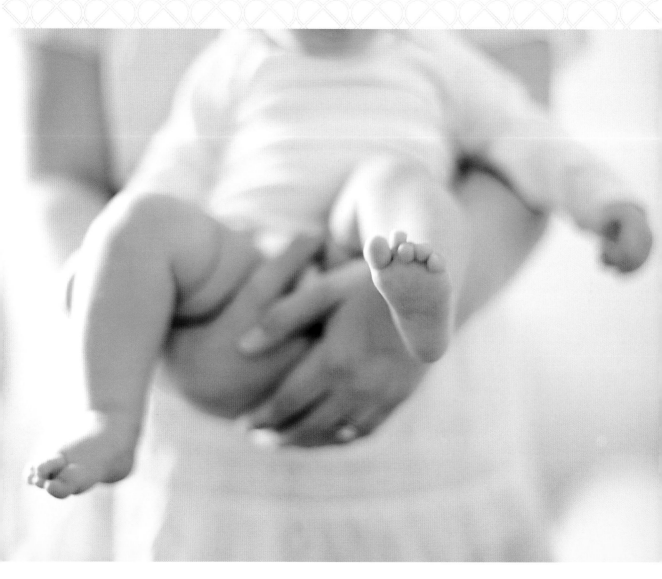

 Mother and baby are positioned next to a window, letting natural light fall over them from the side window. **Contax 645 with 80mm lens, Fujicolor Pro 400H film, f/2 for 1/60 sec., ISO 400**
Photo by Jose Villa

sweet feet

Parents love a special image of their baby's chubby little feet. This shot works best when parent and baby are wearing harmonious tones (white is ideal). The feel of the shot is calm because the baby appears relaxed, even if he's fussing. Babies who can't yet sit up independently will particularly enjoy this position, because it allows them to take in their surroundings. Be on the lookout for little details to include, like mom's wedding ring as she cradles her baby. For another great portrait, grab a vertical shot with both mother and baby's faces in addition to those tiny feet, and don't forget to try a macro lens to define those delicate toes with superb sharpness.

tip **If your budget allows for only one lens for photographing babies, opt for a 50mm prime, a fantastic all-purpose lens. A 50mm is similar to what the human eye sees, so it's a natural choice.**

keep it simple

Baby meets toes in this adorable pose, and a game of peek-a-boo brings on big, gummy grins. The only prop (aside from baby's own feet) is a neutral blanket, something worth keeping on hand. When a bed isn't an option due to poor lighting or clutter, a full beanbag with a soft throw blanket is the perfect portable posing perch. When needed, tweak your color balance for a warmer tone in postprocessing. Cloning out spots of lint from the baby's outfit also prevents unwanted, fuzzy distractions.

tip Stock up on blankets and fabrics with interesting textures and luxurious weaves from discount and fabric stores. Bring a couple to each shoot, and throw them in the wash between uses. These throws also help neutralize any unattractive furnishings. White, cream, and pastels work best with newborns.

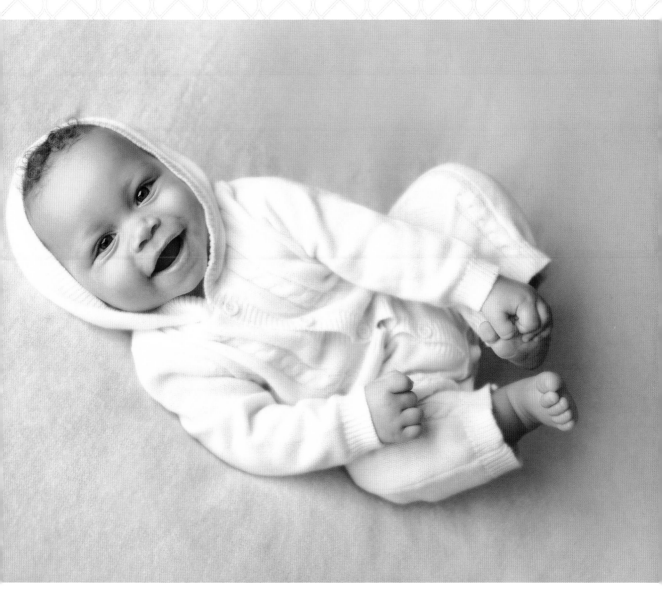

 If you are shooting indoors and far from any soft light source, add strobes and a softbox. Here, dark areas were lightened and large wrinkles cloned out in postprocessing to keep the image as bright and clean as the baby.

28–75mm lens, f/3.5 for 1/200 sec., ISO 160

Photo by Mindy Harris

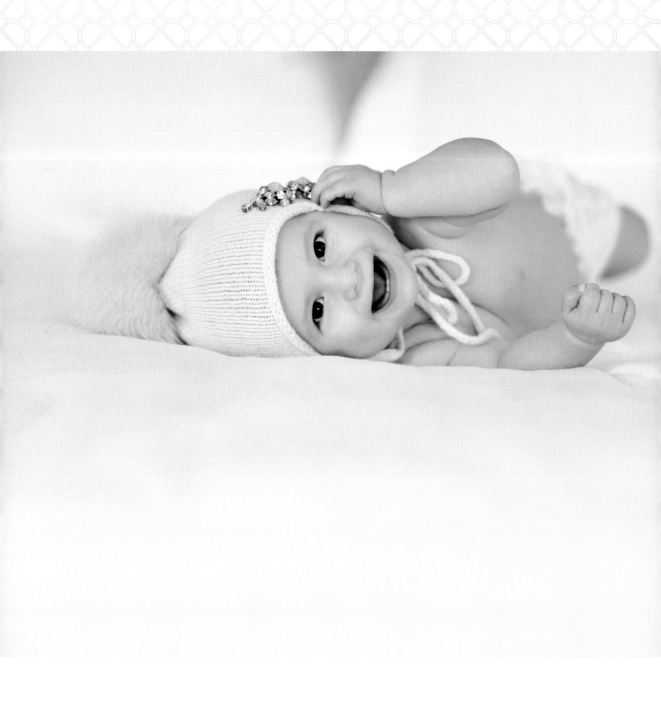

hats off to you

Hats are fabulous. In addition to adding a pop of color, they give babies a safe, soft plaything during sessions. Here, a lovely little lady is having a great time rolling around on the bed with her glamorous ski hat. For a successful hat shot, position the baby on her back or side, and get her to look up at the camera, playing peek-a-boo with a squeaky toy to get her to smile. For another vantage point, stand or kneel on the bed and shoot from above, being careful to keep the camera strap around your neck. Having her lay on her tummy is another appealing pose. Save hat pictures for the end of the session, just in case the baby protests. No one wants an unhappy baby.

tip If the bed has an ostentatious brown-and-gold mushroom comforter from the eighties, strip it! White sheets help reflect light, especially if the master bedroom is dimly lit.

Light from the right corner and bright sheets bathe this beautiful baby in light.

85mm lens, f/2 for 1/500 sec., ISO 800

Photo by little nest portraits

sneak-a-boo

A soft blanket and impromptu game of peek-a-boo create an adorable portrait. Lay the baby on the bed in her diaper, and using care, toss a blanket over her head and gently pull it away while smiling and saying, "Peek-a-boo!" After a few rounds, place the blanket over her, careful not to obstruct her face; as she plays, enthralled with the blanket (or its fringe), cheerfully call, "Peek-a-boo!" and snap a shot of that adorable smile of anticipation.

tip Ask mom to suggest other games that make the baby laugh, and give those a try. Not only will they be helpful in this particular session, but a few new games will help round out your tools for future shoots as well.

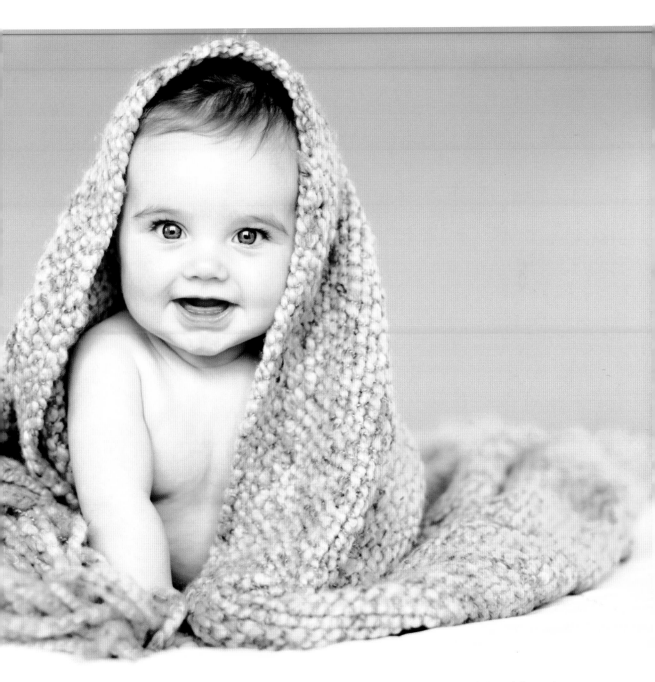

 A giant window casts natural light on the front of the baby, while two lamps on bedside tables create a warm glow in the background and a bit of rim light.

35mm F1.4 lens, f/3.2 for 1/160 sec., ISO 250

Photo by Whitebox

oh, baby!

Clean and simple never looked so sweet. Sometimes the least complicated images make the most thoughtful portraits. Here, the plush carpet texture and beautiful natural light cascading over the baby create a classic portrait parents will treasure. To capture the delectable dimples and rolls in a baby's arms and legs, shoot from above. Try creating interest with negative space and angles, taking care to not center the subject in every image.

tip It's important to stay calm and use a soothing voice during baby sessions. Babies pick up on positive energy, so set a friendly tone with genuine smiles and a soft demeanor. Smiles, silly sounds, and happy faces will help an unsure baby feel more relaxed.

Natural light from a nearby window is soft, serene, and flattering to this baby's delicate complexion. If you're shooting in a dark house, bring a reflector and increase your ISO for the most successful portraits possible.

50mm F1.8 lens, f/1.8 for 1/200 sec., ISO 320
Photo by Sheryll Lynne Photographers

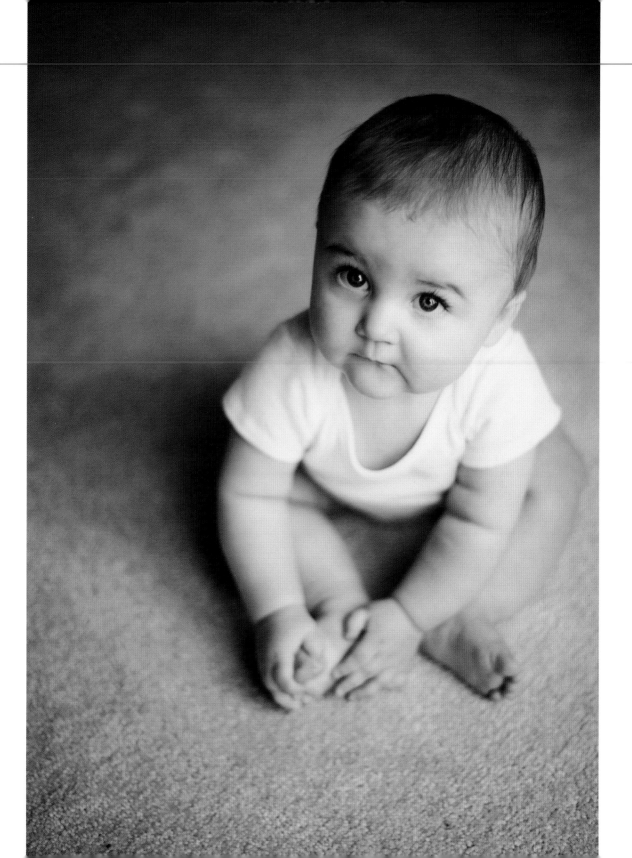

about face

Grouping a family's faces close together in an image shows unity and love. For babies who can sit upright, this perfect pose allows them to interact with their parents at eye level. While mom and dad both kiss their sweet girl, she finds the act hilarious and starts laughing. Gentle raspberries on a baby's cheek will also bring giggles. Photographing the family from above, with their heads together, can create another fun, potentially silly moment.

tip **If a house is cluttered, always head for the bed in the master bedroom, which usually offers a nice, clean space for informal portraits.**

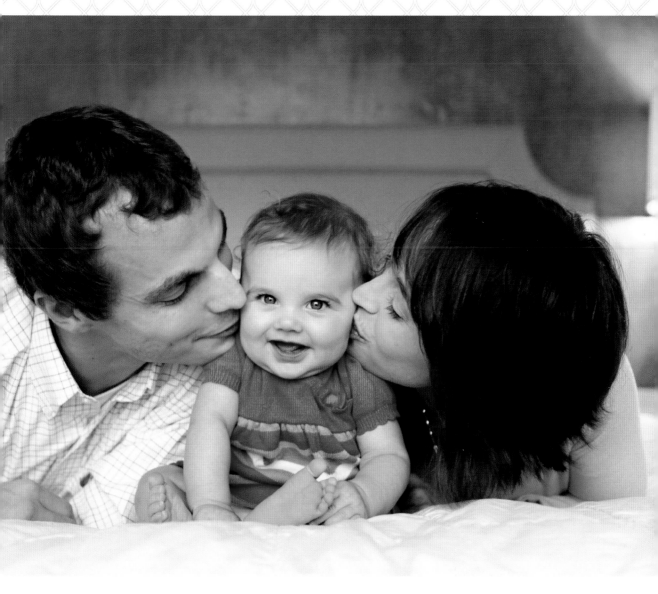

A window and two lamps in the background create a warm glow and a bit of rim light.

35mm F1.4 lens, f/3.2 for 1/100 sec., ISO 1000

Photo by Whitebox

crib notes

A happy baby never needs containment . . . well, almost never. This sweet doll's crib adds both color and a frame for the wee one and is perfect for 6- to 9-month-olds who can sit on their own. For safety, be sure to check for a loose crib bottom, jagged nails, and the possibility of lead paint. And as always when working with babies, have parents standing nearby to serve as extra sets of eyes and hands. For more playtime props, try a little vintage chair or stool and a rocking horse or hobby horse.

tip Babies are often anxious around strangers. Encourage parents to smile, sing, and act silly to make their baby smile. Other grin-getters: a favorite silly song, funny faces, animal sounds, blowing raspberries, or a game of peek-a-boo, with mom or dad jumping out from behind the photographer. Remember to keep it fresh; babies know a one-trick pony.

Mid-morning shade from a tree enhances the colors of the grass, crib, and baby's skin. A little postprocessing contrast boost makes the eyes sparkle.
50mm lens, f/1.6 for 1/1250 sec., ISO 200
Photo by Michelle Huesgen, Untamed Heart Photography

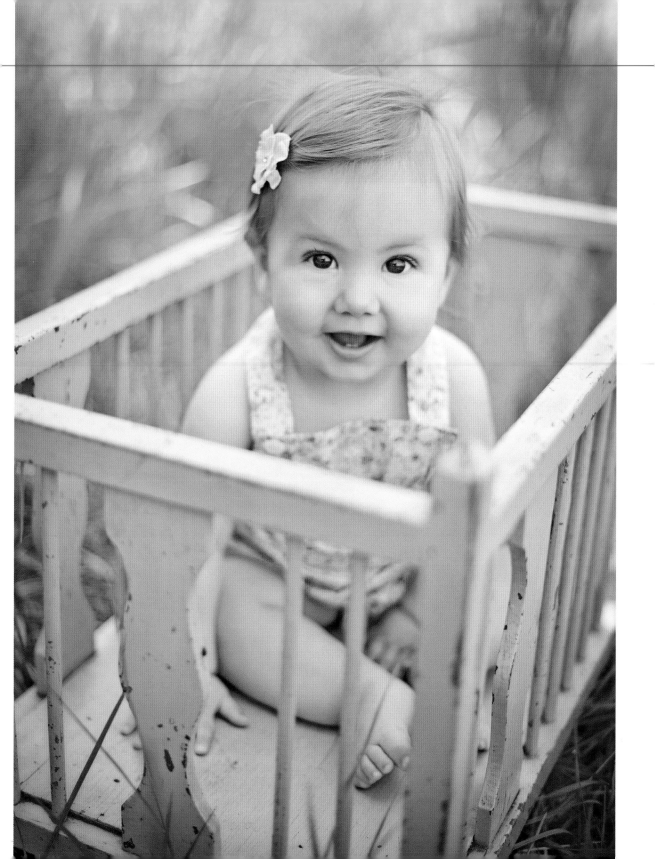

on the up & up

Smiles are a natural reaction for both moms and babies during playtime. For a guaranteed favorite, have mom sit comfortably on the bed and lean against the frame for support. Ask her to lift her naked baby up and play with him. Whether mom's mouth is open during play or is engaged in a serene smile, make sure to catch her face at its most flattering. Also, remind mom that accidents sometimes result from an undiapered baby. It's not a bad idea to save this shot for later, just in case mom needs to change her top. For an alternative, ask mom to take this same pose but move in for a kiss on her baby's face.

tip For perfect naked-baby portraits, remove socks and diaper in advance to allow elastic marks to fade. Keep wipes, diapers, and burping cloths nearby in the event of SBE (spontaneous baby emissions).

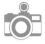 Whenever you're faced with meager light, as here, raise your ISO to improve the exposure of the image.
50mm lens, f/3.2 for 1/200 sec., ISO 4000
Photo by Mindy Harris

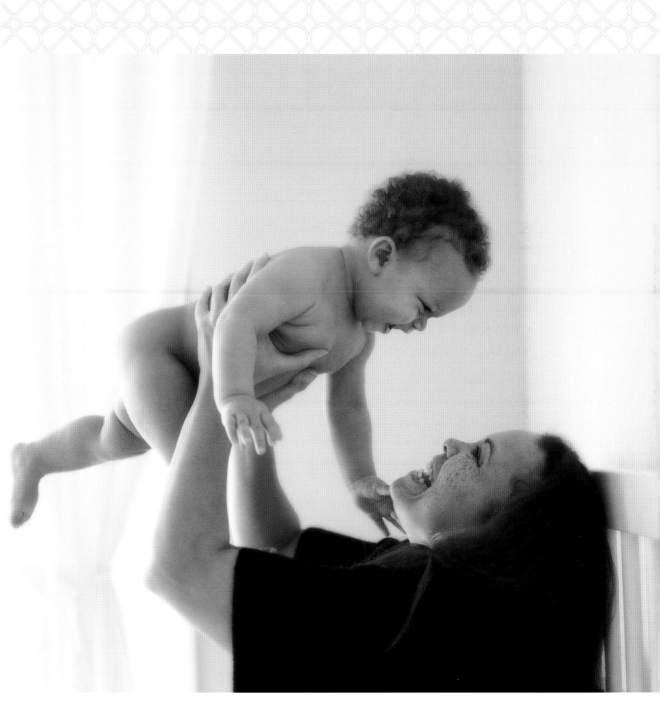

in touch

Mom's shoulder is a safe haven, especially when the baby is still warming up to the photographer. What's more, mom doesn't need to be coached to smile in this pose—it's a natural response to hugging her baby. Use a shallow depth of field to keep the baby in sharp focus and let mom blur in the background. Another precious portrait idea: move behind mom (while the baby rests on her shoulder) for a clear view of the baby's face.

tip Young babies are happiest in the morning after their first nap, so take advantage of this window of bliss.

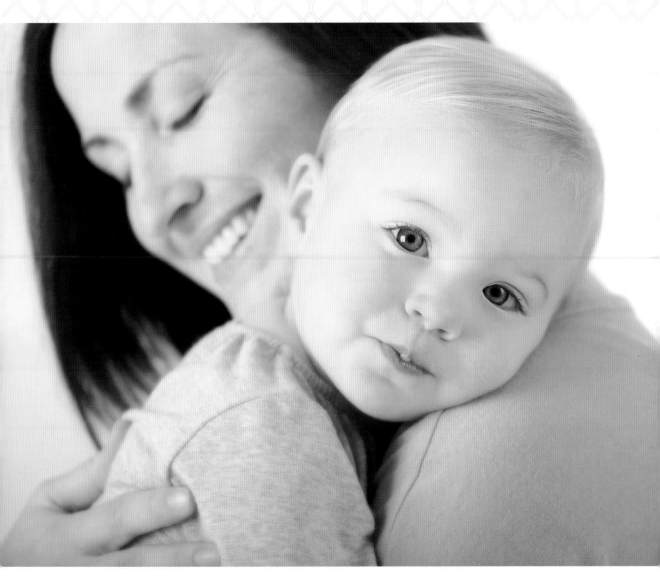

 If you're shooting on a cloudy day and using indoor lighting, place mom and baby next to the brightest window in the house. For this image, the color balance was adjusted in postprocessing to add a slightly pink tone.

28–75mm lens, f/3.2 for 1/200 sec., ISO 800

Photo by Mindy Harris

daddy's darling

A father and his baby together make treasured, important images. Photographing this sweet moment between a daughter and her dad also gives mom a quick break; photographing the baby separately with each parent—even when parents are tired—is a must. Have dad stand near a window for the best, most flattering light, and ask him to hold the baby in whatever way feels most natural. Dad holding the baby cheek to cheek, or giving her a kiss on the cheek, makes another beautiful portrait. Here, the custom-embroidered diaper cover is adorable and provides an opportunity for another capture; parents appreciate attention given to documenting these sorts of details.

tip Make backgrounds as simple as possible to keep the focus where it belongs: on the connection between your subjects. If the background is cluttered, ask permission to remove items temporarily. A shallow depth of field will also blur the background and keep the focus right where you want it.

This room was fairly dark; pulling all coverings away from the window, coupled with a higher ISO, created a lovely image.
85mm lens, f/2.8 for 1/320 sec., ISO 800
Photo by little nest portraits

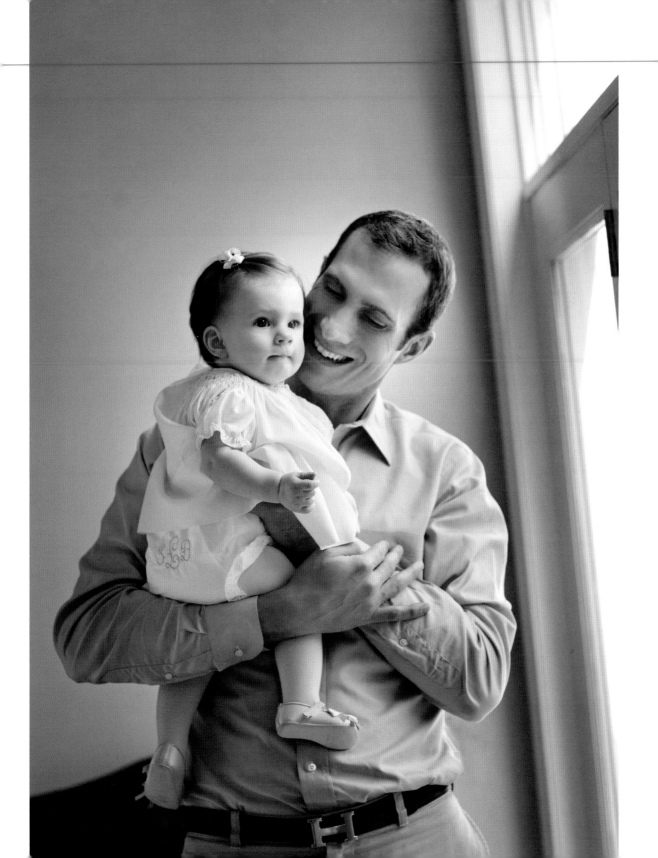

sink & swim

Most babies bathe in the sink, so why not use the spot for a whimsical portrait? Place a folded hand towel in the basin first to create a nonslip surface, fill the basin with a bit of lukewarm water, and then touch the faucet to ensure the metal is a comfortable temperature. Keeping mom or a spotter nearby, place the baby sideways in the sink so that he can use the spout as a handle. If the window light is to the side or front, take advantage of natural light "washing" over the baby. If the window light is coming from behind, expose for the shadows and blow out the background for a bright, clean shot. For more portraits, bring mom in to interact with the baby and wrap him in a fluffy white towel. Note that this pose should only be used for babies who are able to sit firmly on their own.

tip Familiarity will make this potentially awkward setup less stressful for the baby (and mom), so spend a little time getting him acclimated to the water before you start shooting.

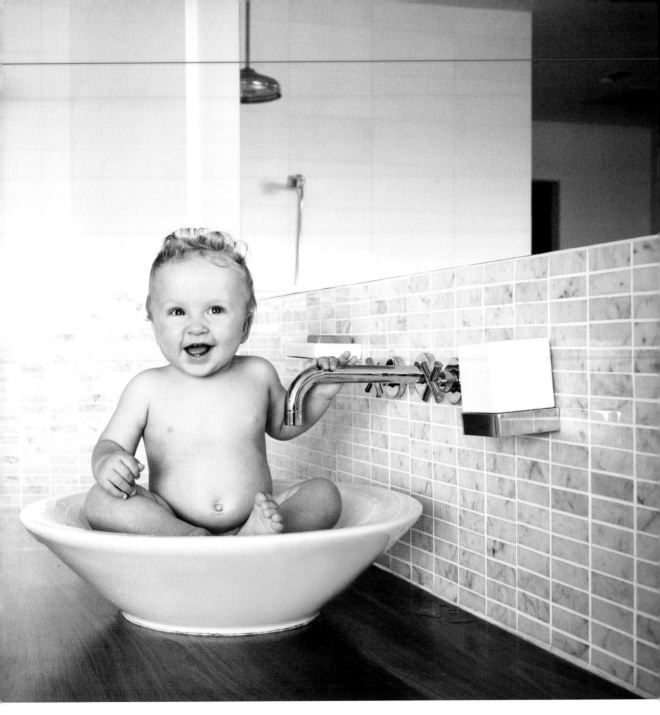

 White tile, a white ceiling, and a mirror all act as natural reflectors for the window light, lending to this serene, clean scene.

24–70mm F2.8 lens, f/4 for 1/160 sec., ISO 200

Photo by Lena Hyde Photography

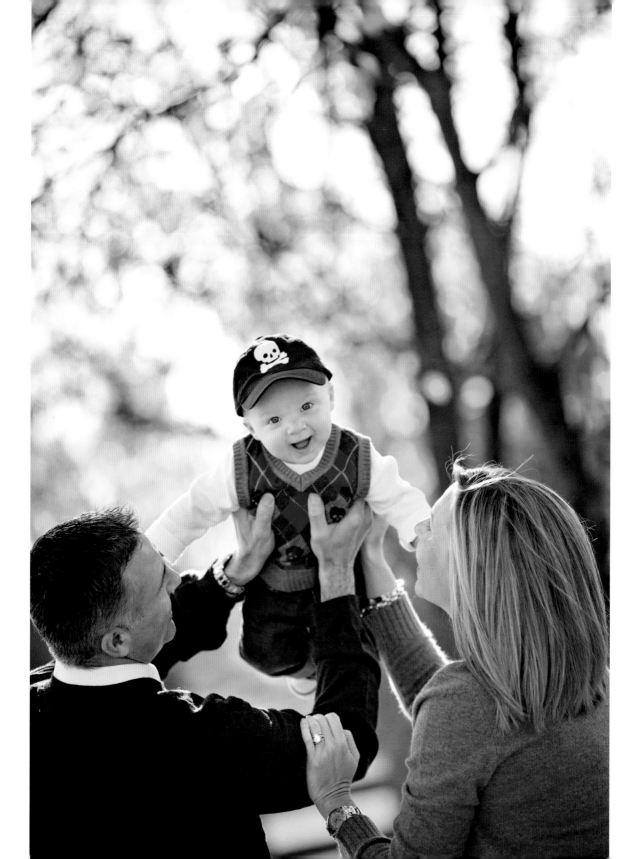

up in arms

Up, up, and away! Many babies love pretending to fly. To capture this fun moment, use a fast shutter speed to avoid blur and a shallow depth of field to let the leaves in the background add atmosphere without stealing the scene. Make sure everyone's hands are connected to show love and closeness in the family. For a second capture from the same pose, zoom in a bit tighter for a close-up of the baby's excited face. The result: a no-cape-needed peek at an intimate, spontaneous-seeming moment between parents and their young son on a crisp autumn afternoon.

tip Having mom and dad safely swing baby between them and close to the ground is another exciting way to elicit smiles, and it allows for a delectable child's-eye-level capture.

Fall trees provide both shade and a colorful background for this precious park portrait.

135mm lens, f/2.2 for 1/1600 sec., ISO 400

Photo by little nest portraits

A to ZZZs

There is magic in a baby's bedroom. Parents treasure nursery photos of their children and, in particular, those taken in a baby's own crib. The crib represents an important place during a special first year that so quickly passes. Cribs are typically safe, but this little guy is just starting to stand with the aid of holding on to furniture, so his mom is just out of the frame, ready to help if he gets into trouble. For another crib shot, capture the baby sitting in the corner and looking up at the camera as he holds his favorite blanket, teddy bear, or doll.

tip If your pint-size model is less than excited about going into his crib when it's not nap time, have mom keep some incentive on hand in the form of a healthy, age-appropriate snack, like Cheerios.

In this dimly lit room, the shutter speed was lowered to 1/125 sec. to bring in as much light as possible.
24–70mm F2.8 lens at 50mm, f/2.8 for 1/125 sec., ISO 1600
Photo by Anna Mayer

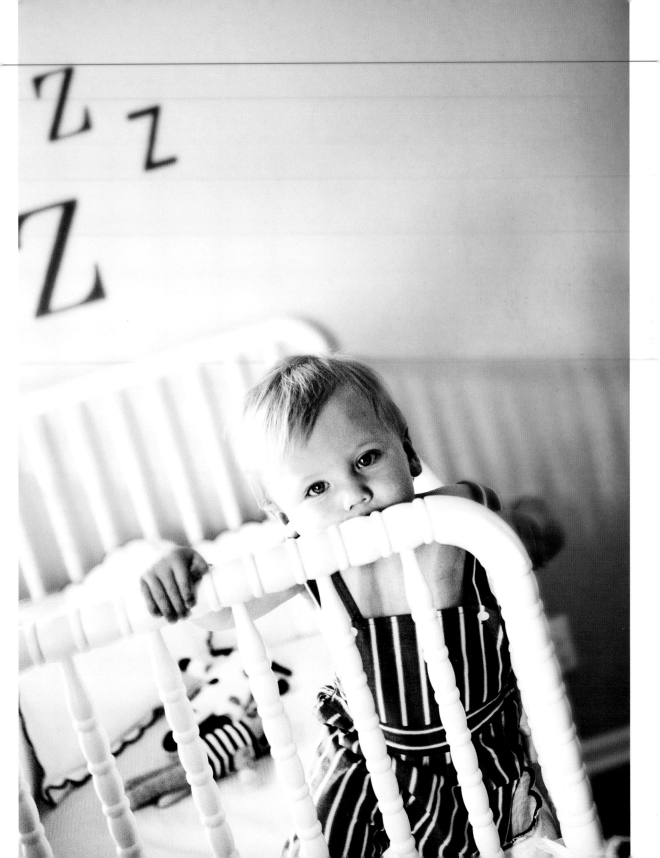

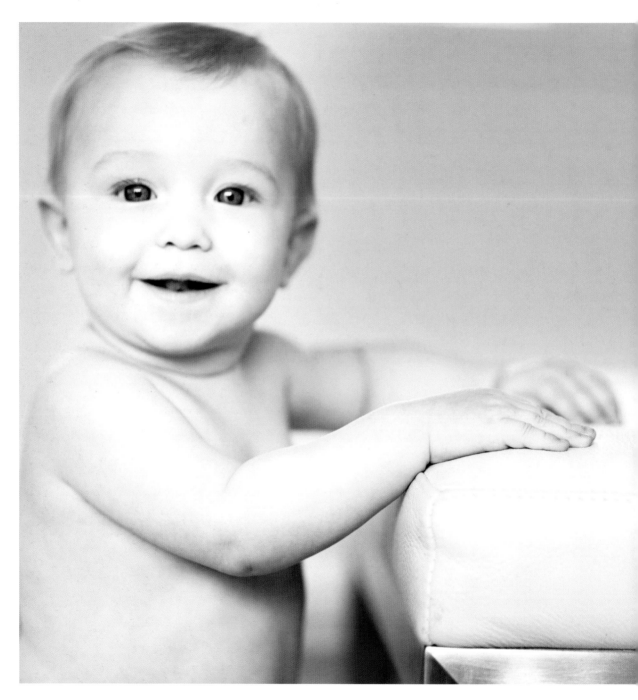

Ample windows bathe this bright children's photography studio in indirect sunlight.

85mm lens, f/2.5 for 1/160 sec., ISO 320

Photo by little nest portraits

pull up

Everything's coming up poses when a baby is learning to pull herself up. Have a stable, preferably soft ottoman or stool, or a wall, to stabilize a newly standing tot. For something unexpected and fun, photograph from the side and shoot off-center. For a follow-up shot, climb onto a chair and shoot from above for a different, playful perspective.

> tip Crop images in-camera during the session to show clients instantly how their images will look.

beach baby beauty

Dandy and sandy, a covered wooden sandbox and colorful array of toys create a bodacious beach scene. An umbrella shades the baby's delicate skin, and native plants in the background add color and definition without upstaging the subject. Letting little ones play in their natural surroundings allows them to feel more comfortable and results in a relaxed portrait. Here, dogs playing on the deck just to camera right catch the baby's attention and result in a big smile. Keep colorful sunglasses and a cute beach hat on hand for additional close-up portraits. Letting the baby water flowers or even run through sprinklers at the end of the session is another way to create treasured portraits.

tip Always save the fun, messy shots for last so that the baby can go right into the tub when done with the session.

Light bounces off of a light wall and onto the baby's face, acting as a natural reflector.
60mm F2.8 lens, f/6.3 for 1/200 sec., ISO 320
Photo by Rachel Devine Photography

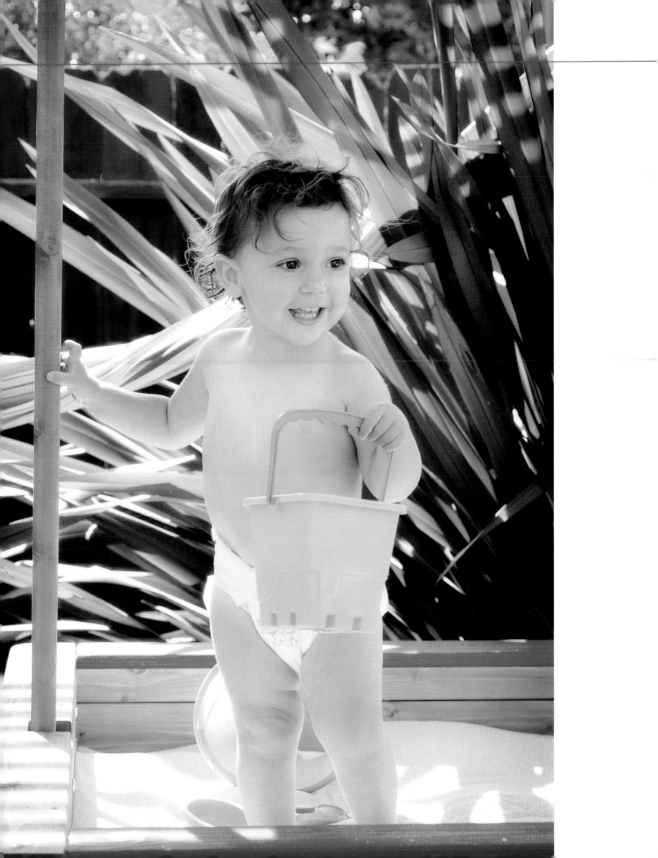

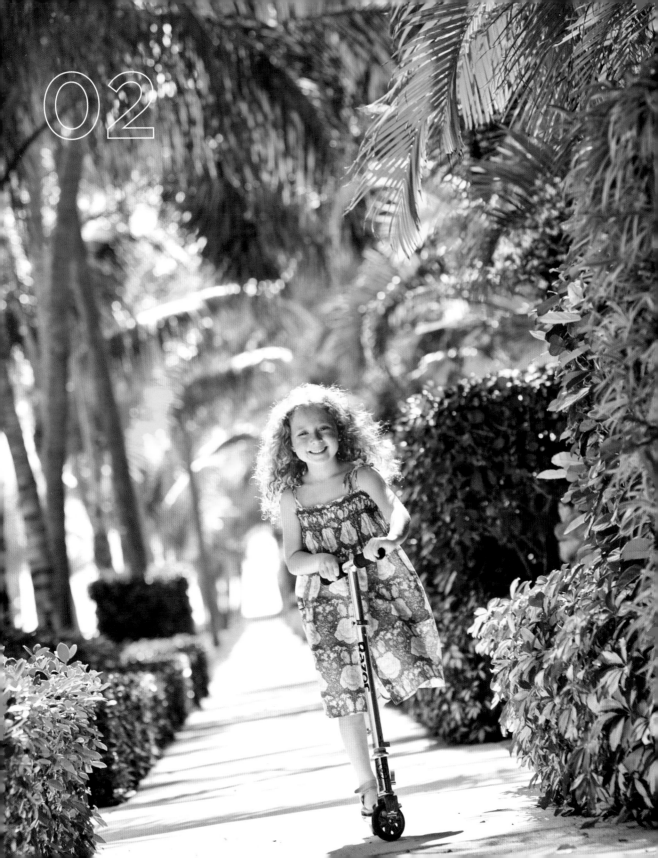

02

children

Filled with boundless energy, children can keep you constantly on the go. And why not? A child's world is full of wonder and excitement, and children investigate everything, from the smallest crack in the pavement to the big, blue sky.

Start any session by spending a few minutes with your small subjects, keeping your gear in the bag so that it doesn't intimidate them. Kneel down to their level, and show genuine interest in getting to know them first.

It's best to schedule sessions for the morning, when kids are most fresh. Never push worn-out children, because they might recover from one tantrum but not from two. Make sure everyone is healthy; sick kids do not appreciate being photographed.

Children often feel exhilarated in new environments, especially when something can be scaled, jumped over, or used for a moment of play, so safety considerations are important. Keep sessions fun and always moving. Allow climbing (when safe), but save running and jumping for the end of the session after the desired shots are captured.

Portraits make young people feel special and connected to their surroundings. Because parents are wonderful models for child behavior, be sure to have them give plenty of praise for positive attitudes and behaviors.

With creativity, a song in your heart, a willingness to moo like a cow, and the stealthy nimbleness of a cat, you can make sessions with children at once charming and creative, sweet and disarming, and, most of all, something to be remembered for the ages.

Photo by Lena Hyde Photography

all about perspective

Be sure to get low and find new perspectives to capture toddlers. Framing this composition is a clever bike rack, and this wee one is short enough to make peeking out a blast. Crouch to get in there, make him laugh, and play peek-a-boo to keep interest (and to ensure the busy boy remains in the middle of the frame). For a second capture, have him hang straight-armed from the rack and swing his legs.

tip Getting children involved is important, whether they help load a film camera or play on the floor with the photographer as part of the session experience.

Here, a cloudy day creates nice, diffused light from all angles.
24–70mm lens, f/5.6 for 1/120 sec., ISO 800
Photo by Milou + Olin

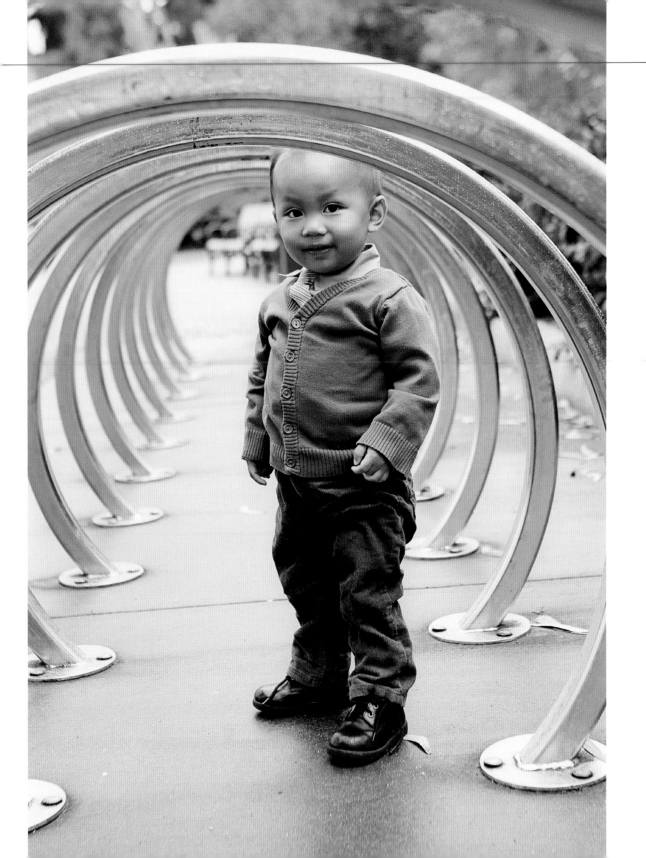

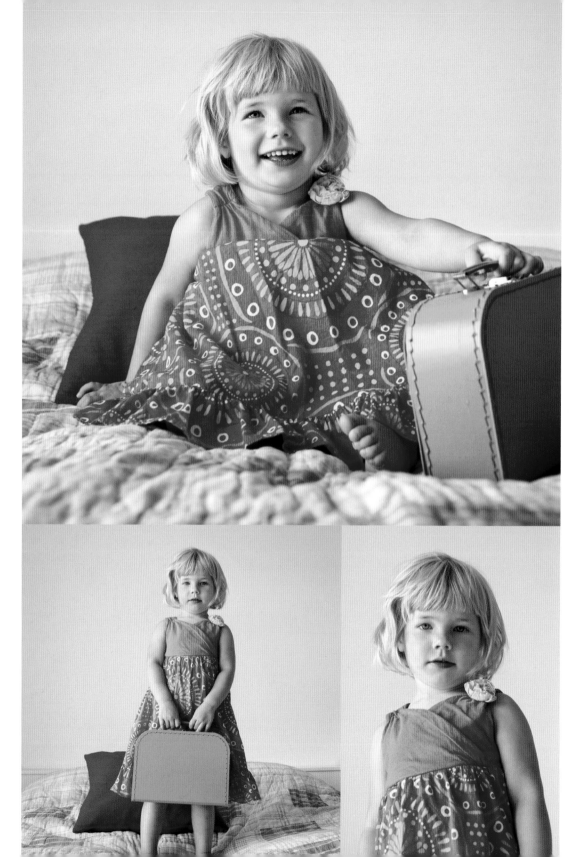

have suitcase, will travel

Pulling personal possessions from a child's room creates a more personal, relevant shoot. Here, a cute little suitcase is a welcome addition; equally perfect props could be a favorite toy or book. For this terrific triptych (captured in less than two minutes), ask your subject to hop on the bed, right in the center for safety, and then hand her the little suitcase (or any item). The first image is a close crop, a solid portrait without the prop. The second is a fabulous full-body portrait. The last is a perfectly pleasing plop down on the bed.

tip Save jumping-on-the-bed shots for the end of the session in case things get a little crazy. It is almost impossible to regain a child's attention after so much fun.

Even with a bank of windows to camera right, this room was both very pink and not supersunny, necessitating a higher ISO.
28–70mm lens, f/4 for 1/60 sec., ISO 800
Photos by Lena Hyde Photography

up, up, & away

This Supergirl gleefully flaunts her hidden identity in her bucolic, superheroine hideaway. Capes are wonderful for poses, because they give kids the license to have some fun. Here, tall grass necessitates exaggerated, hiked-up-leg steps to keep this girl wonder from tripping, her cape flowing in unexpected gale-force winds. To add a "super" flourish for another shot, ask her to put her hands on hips like she's the boss; then zoom in tighter and go vertical. Asking her to pretend to fly creates yet another super shot.

tip Make sure to capture in-between moments during the shoot by keeping the camera ready at all times. Even quick breaks for snacks and rest can lead to beautiful portraits in which kids who feel the need to be "on" in front of the camera can be themselves.

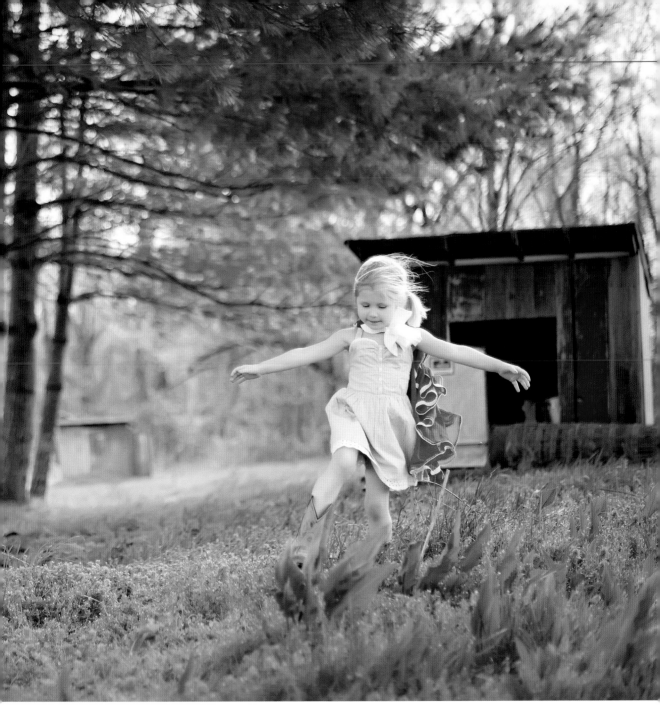

 With the sun just about straight ahead, this image was captured mid-afternoon for beautiful light.

50mm lens, f/1.4 for 1/1250 sec., ISO 200

Photo by Michelle Huesgen, Untamed Heart Photography

pre-GQ

This cute Casanova is ready to steal many a construction-paper heart before naptime. Ask your little subject, ideally dressed to kill in modern casual, to put his hands in his back pockets. (Demonstrate what to do if he has trouble with verbal cues.) After grabbing a few photos from the front, tell him to freeze. For the great attitude grab, run behind him and have him turn around and look over his shoulder. Asking him to be serious ensures a smirk, as keeping a straight face is virtually impossible for kids.

tip When photographing smaller kids on sidewalks, keep a responsible grown-up between your subject(s) and the curb. Little ones will often attempt to run into the road.

Here, buildings block out the strong, directional sun. To prevent squinting, make sure the subject isn't looking into strong, reflective light.

70-200mm F2.8 lens, f/3.5 for 1/160 sec., ISO 100

Photo by Lena Hyde Photography

slide rule

Playgrounds are a natural habitat for children: The equipment is typically not intimidating, lends fun and bright colors to images, and personifies childhood. When younger kids just want to have fun, allowing them to explore a playground is a win-win; they have a good time while expending energy, and the photographer garners dynamic lens time. In this image, a young girl who loves to play hard and dress pretty offers a genuine, sweet smile. Photograph your subject at the bottom of the slide for a quick second image, making sure to use a fast shutter speed to capture every moment.

tip Try not to hold rigid expectations for how a playground shoot will unfold. Allow the child to participate and make decisions. This is where the real magic happens.

Beautiful afternoon sunlight streams in from behind, creating a halo of light around this little girl's head.
80mm Zeiss lens, 120 Kodak 800 film, f/2 for 1/125 sec.
Photo by Elizabeth Messina Photography

head & shoulders above

Look for natural interactions between parents and their kids. This perfect pose suits a child old enough to stay balanced and a parent-kid duo used to this type of play. (Keep younger kids seated to prevent falls.) Get both faces in the image, and keep the vibe relaxed for the most casual, timeless captures. Another sure shot: With the child seated on dad's shoulders, have dad walk so that you can take a candid portrait. Grab a third picture from behind, asking dad to walk away from you while the child looks back at the camera.

tip Show your subjects relaxed and connected even if they aren't facing or looking at each other.

As the sun sank lower in the sky, the subjects turned, so the light struck the sides of their faces here.
135mm lens, f/4 for 1/500 sec., ISO 320
Photo by Mindy Harris

make a swish

Sweet as a summer flower, this fresh meadow portrait requires only a young girl, some attitude, and a fun, flippy skirt. The power of this image comes from the young girl's happiness and her wardrobe, a perfect girly-girl and tomboy mix. Little girls love to be dramatic, whether good or bad, so get your subject to respond in a big way by having her flounce her skirt and then telling her a funny joke. If you're photographing in a field, get a second portrait by having her crouch low so that she is immersed in the wildflowers; zoom in tighter and get down to her eye level for the right perspective.

tip When photographing kids, silliness is key. Get a parent to stand behind the lens and do something totally unexpected. A little wiggle or funny dance can make any kids smile, even if they're a little too cool in the beginning of the session.

In an open field, overcast at mid-afternoon, the sun was just to the front-left of the camera, alleviating dark shadows and keeping distracting hotspots from the subject's head and shoulders.

50mm lens, f/1.4 for 1/2000 sec., ISO 200

Photo by Michelle Huesgen, Untamed Heart Photography

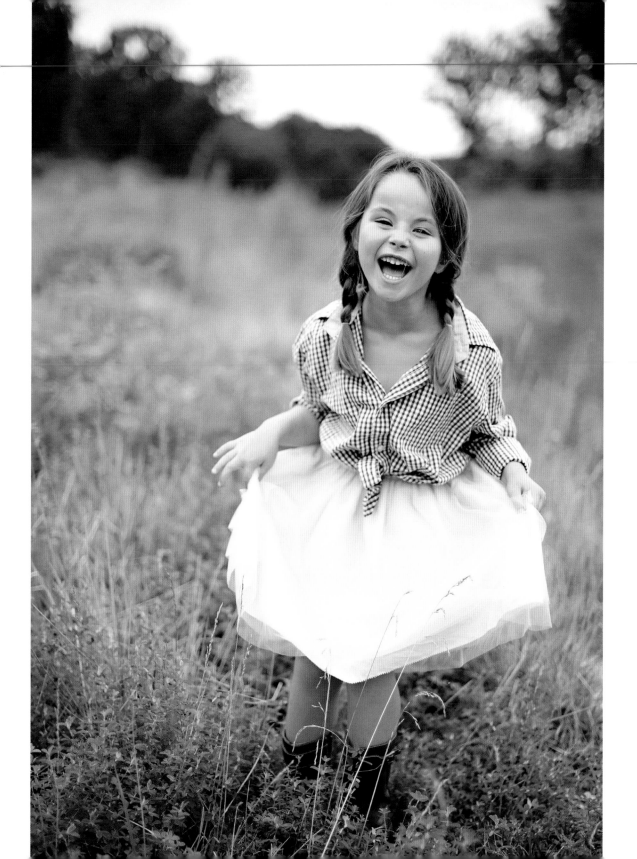

prop to it

Styled sessions are fun when your subject has a specific passion, so work with his interests in mind. One meaningful item will always beat too many props in an image. Here, the boy's delectable yellow airplane provides inspiration, without taking away from the little subject. While keeping the camera eye level with your young flying ace (or any child), have the child crouch down next to the prop to capture both in the frame. Since the hood and airplane provide the only color, the result is a predominantly monochromatic scene. When you incorporate the child's own interests, very little prompting will be necessary; just let him play and occasionally ask questions to bring forth eye contact and facial response. For a second capture, try a tight crop of the adorable pilot's face with goggles.

> tip Unconventional backdrops, and even flooring, lend depth and added character to the young subject being photographed.

Natural light in this studio provides ample brightness for both the airplane and the pint-sized pilot.
85mm F1.2 lens, f/1.6 for 1/1250 sec., ISO 250
Photo by Shannon Sewell

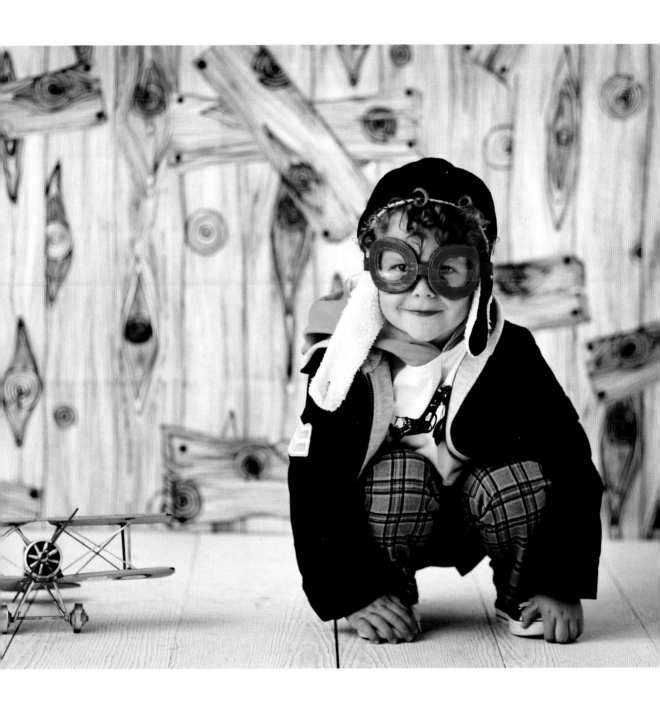

cover girl

When capturing children naturally, setting up a composition and then documenting the expectant moments before a big laugh or a reaction creates dynamic, beautiful photographs. Here, the subject's vibrant eyes and the anticipation of a big laugh steal the scene in this scrumptious image. The simple flowers of her headpiece add a slightly styled feel. Talk, joke, and interact, grabbing different expressions as she reacts, and keep shooting, even while the mood is changing. Get her hands on her hips (out of the picture), too, and have her clasp her hands behind her back or hold a flower for a full-length portrait.

tip Remember, on a tight crop even events and things outside of the frame (for example, the hands on the hips) help tell the story.

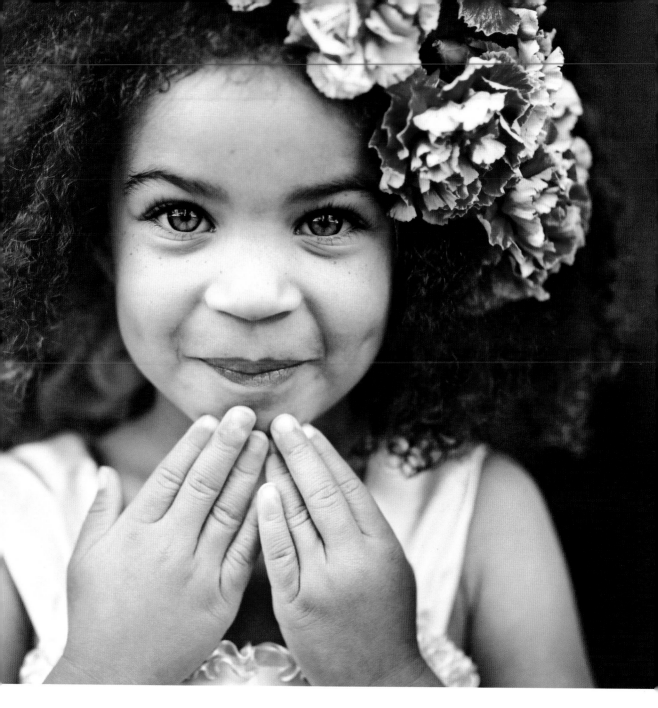

 This capture was taken just inside the shade of some trees. A very light lavender wash over the top in postprocessing lends a softer feel.

85mm F1.2 lens, f/1.8 for 1/1000 sec., ISO 320

Photo by Shannon Sewell

plenty of attitude

Dressing a cute kid in "mature" clothing creates the opportunity for a lot of fun and laughing shots, as well as serious ones, too. Ask the subject to lean against a wall, cross his arms, and give a tiny smile for the perfect, semiserious expression. Having him keep his hands in his pockets results in a more natural and less posed look. Other captures to bring out an "old man" character: feeding pigeons in the park and yelling at kids to get off of his lawn. Okay, maybe not so much that last one.

tip Layers of clothing are adaptable and perfect for portraits: cardigans can be on or off, shirts buttoned or unbuttoned, cuffs turned up or left down, shirttails hanging out or tucked in, and ties worn loose, cinched up, or not at all.

Open shade keeps this cool cat from overheating in the hot weather and adds to the image's downtown-storefront vibe.
85mm F1.2 lens, f/2.2 for 1/250 sec., ISO 100
Photo by Whitebox

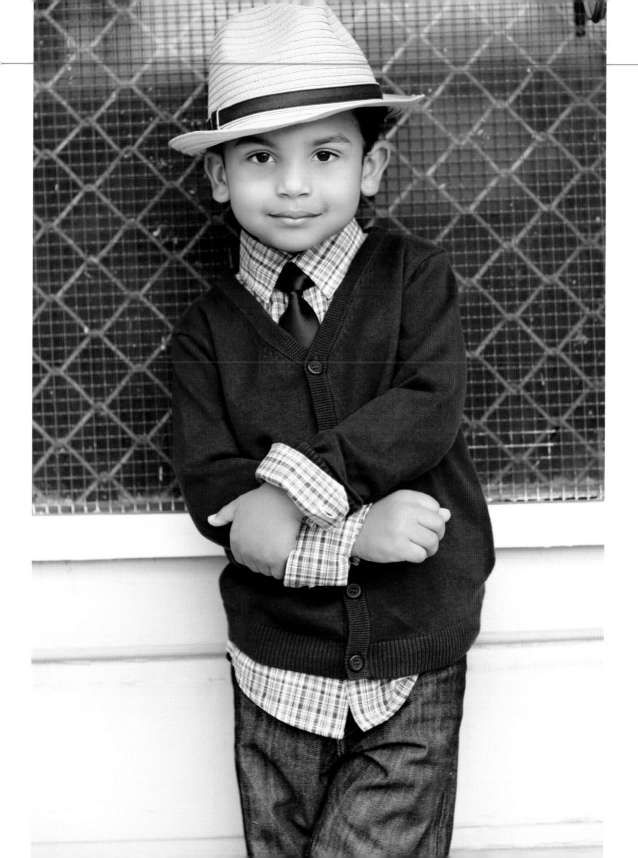

what a
character

Kids love to play make-believe, and capturing them in costumes lets them step outside of themselves and into a magical world for just a little while. Stretch creativity by planning a full, pretend-play session based on the child's interests. If a child is unaware of the character he's portraying, give the details and let him apply his interpretations. This "Middle Earth" session is a perfect example. A tree stump provides the perfect natural prop for crouching. Dressed as a hobbit, the subject is amply prepped for the character and is excited to go barefoot. For a perfect second capture, have him peek out from behind a tree, making sure his head is craned out comfortably and far enough for the portrait.

tip By scheduling fantasy minisessions near Halloween, you can work with a cavalcade of colorful characters and further hone your skills at capturing the whimsy of youth.

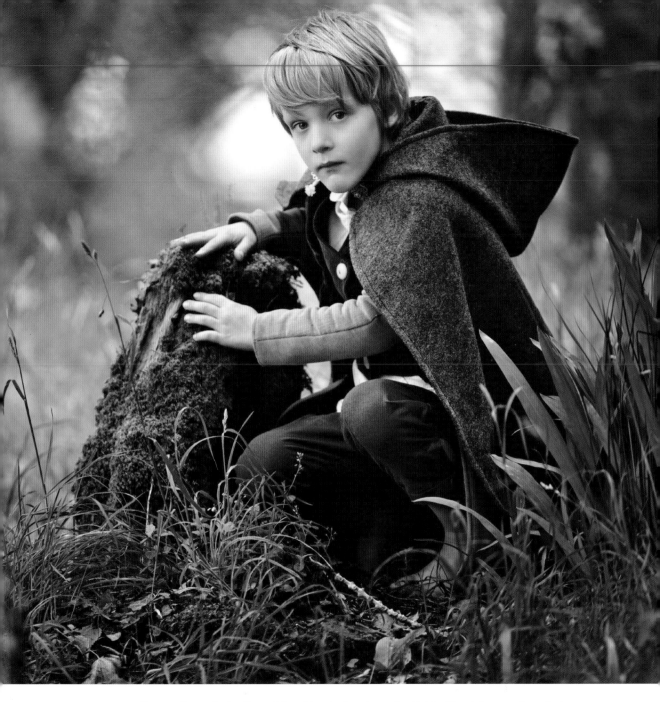

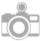

Open shade allows this subject to face incoming light without the use of a reflector.

300mm F2.8 IS USM lens, f/2.8 for 1/250 sec., ISO 640

Photo by Blue Lily Photography

ground cover

Soft, diffused light coupled with deep-green grass creates a sweet, pastoral capture. Ask your subject to lie down on the grass, and play peek-a-boo while standing over him. Keep the camera strap around your neck to avoid dropping your gear. Alternate between hiding behind the camera and peeking over it at him while he peeks back at you. This results in a series of natural, playful expressions. Grab a second shot by having him rest on his stomach looking up at the camera, experimenting with different angles for even greater interest and variety.

tip **To protect little eyes from blinding light, have an assistant or parent hold a reflector to block out the sun, or place your subject in the shade.**

The diffused, overcast light in this image, taken near the San Francisco Bay, ensures the boy's face is evenly lit and without shadows.

24mm F1.4 lens, f/2.8 for 1/800 sec., ISO 100

Photo by The Image Is Found

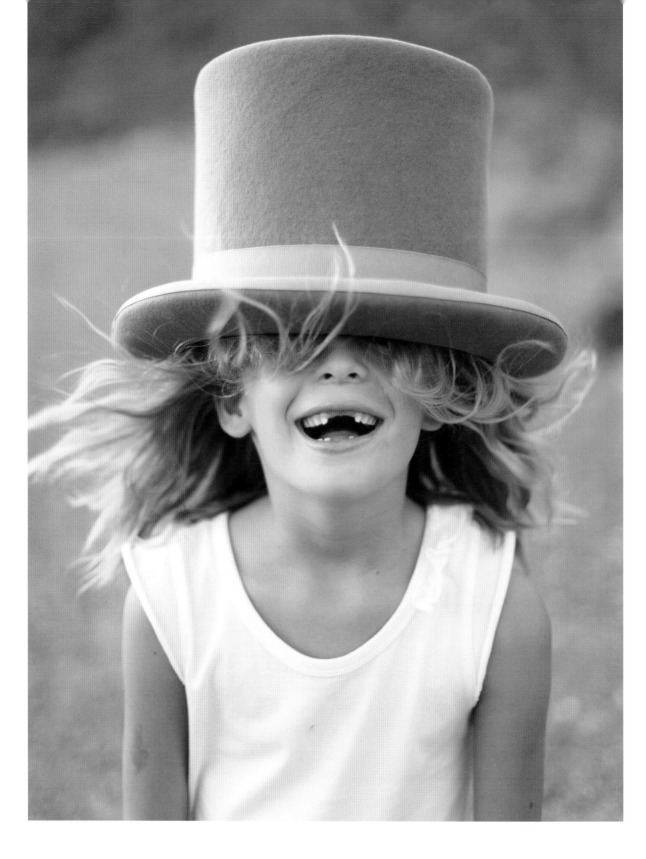

brimming with
personality

A too-big vintage top hat plus a rambunctious little girl equals laughter when the headwear covers her eyes. First, capture her small hands holding the sides of the hat up, so it appears to fit; then keep your camera at the ready for sweet, in-between moments. Here, a wind gusts for a lovely moment of surprise.

tip Even if kids are missing teeth, don't put off portraits. Important events like the loss of teeth are so fleeting, why not capture them?

Late-afternoon sunlight means pure magic. The last hour of light is the most flattering, so check sunset times.
80mm Zeiss lens, 120 Fuji NHP 400 film, f/2 for 1/60 sec.
Photo by Elizabeth Messina Photography

stumped

Tree stumps provide natural thrones, the perfect pedestals for center stage. Placing children anywhere off the ground creates a falling risk, but tree stumps are usually solid and not that high, so your subject can most likely hoist himself up. You can find them in most urban parks, and they provide the added bonus of allowing your young subject to show off his mad climbing skills. For a second capture, have your subject lean against a nearby fence, which still allows him to share his charm and confidence.

tip It might be instinctual to remove friendship bracelets and other accessories, but since they represent a stage of the child's life, they should be incorporated whenever it makes sense.

This open tree shade is bright and even, allowing the background to appear as bright as the subject.
90mm F2.8 macro lens, f/3.2 for 1/320 sec., ISO 320
Photo by Rachel Devine Photography

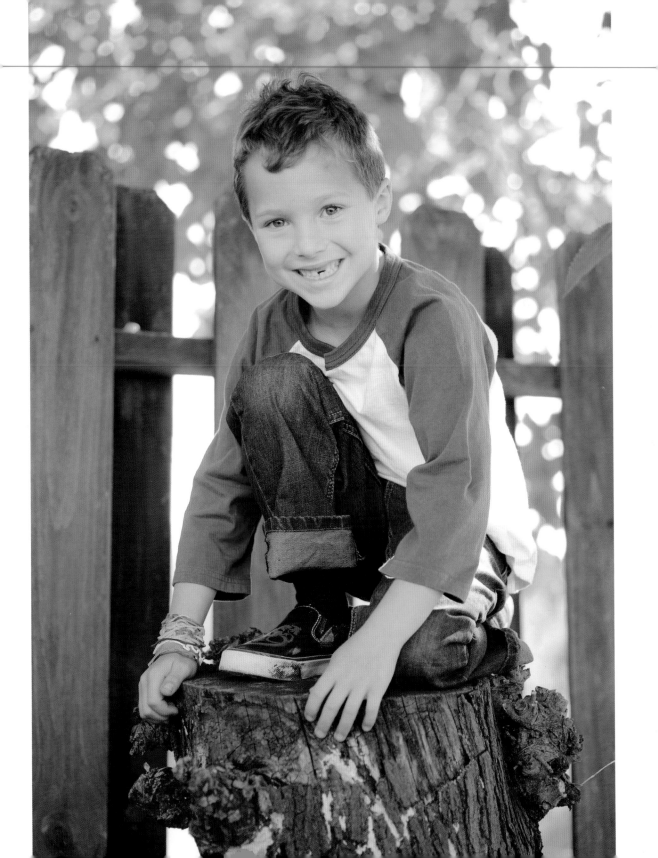

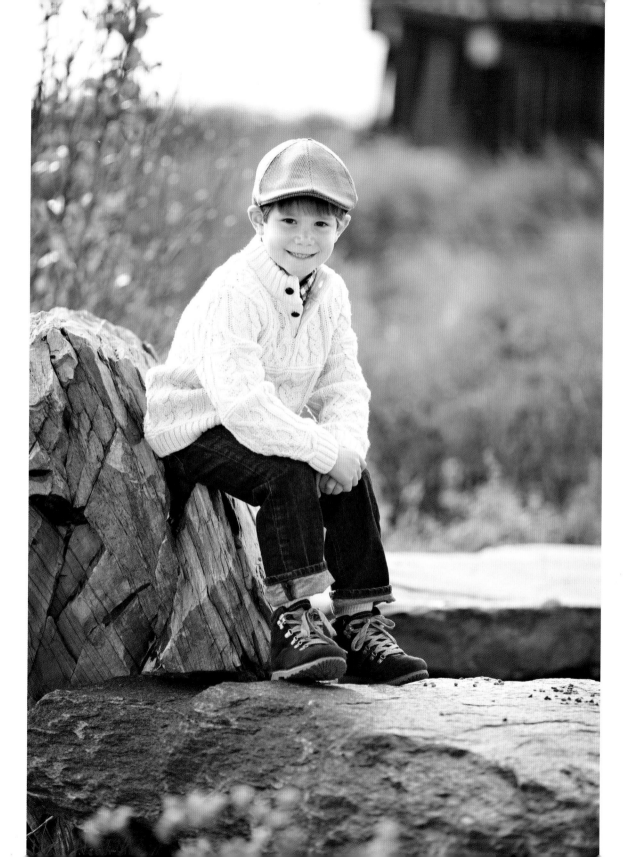

rock it out

Boulders and other natural platforms are less formal as seats and make your subject feel more grown-up, cool, and confident. A side view makes the portrait more dynamic, and framing the subject with flowers and other scenic elements, like the older structure in the back of this photograph, lends depth and interest. For another capture, have your subject look out into the distance, and pull back for a wider, environmental shot.

> tip Play with angles in wide, environmental shots to incorporate as much of the surrounding area as possible.

A slightly overcast day means even light and less glare or squinting.
135mm lens, f/2.8 for 1/800 sec., ISO 250
Photo by little nest portraits

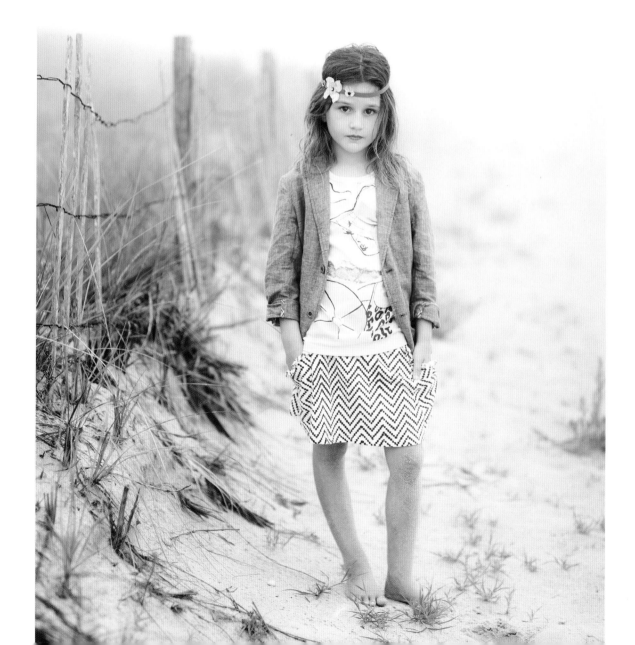

making waves

This hip photo from a session at the beach isn't a typical capture. While it's so easy to place a subject in front of an object, this unexpected positioning to the side of the fence, parallel to it, creates an innovative image. Use a shallow depth of field to keep the young lady sharp and the fence blurred. Have her keep her hands in her pockets to show confidence, and if it's safe, have her go without shoes to connect her naturally to the beach scene. To grab a second picture, zoom tighter for a portrait shot, and smile and joke with her to bring forth the grins.

tip Even when it's cool and overcast, bring water for hydration and natural insect repellant if the bugs are biting.

A foggy evening with natural light lends to the casual mood.
85mm lens, f/2.5 for 1/400 sec., ISO 400
Photo by little nest portraits

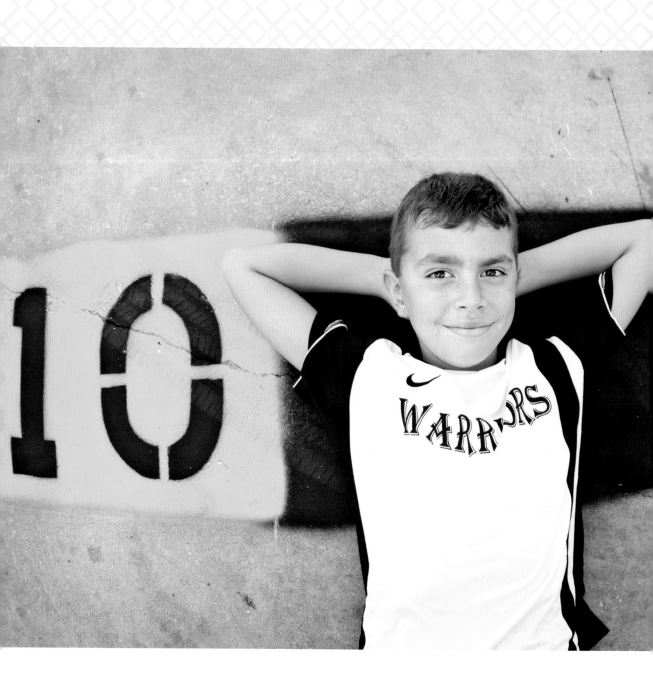

grounded

Where there's an excellent photo opportunity at "ground level" (here, on a parking lot where a numbered parking space matches the subject's age), instruct kids to comfortably rest on their backs for a quick capture. Here, this cool cat places his hands behind his head as a cushion against the hard surface—and to lend a simple, carefree vibe. A fish-eye lens creates a fun, photographic angle and is especially useful when the photo is taken from a standing position without a ladder or stool on hand for extra height.

For great grins, get kids laughing by telling jokes, making silly faces, or tickling their bellies (ask parents to be sure physical contact is all right). Line up your lens at "eye level" with the child, and always ensure your camera strap is secure to prevent slippage.

tip A specialty lens, like the fish-eye, is fun for a few shots at sessions, but place your focal point in the center of the composition, or there will be serious distortion.

For this brightly lit morning scene, the father's SUV lent the perfect amount of shade.
15mm fish-eye lens, f/4 for 1/640 sec., ISO 100
Photo by Anna Mayer

up a tree

Low, strong trees—whether found in a park or your subject's backyard—present an opportunity for veteran tree climbers. Here, the double trunk notch creates a fantastic frame for the child, while the leafy canopy adds detail and layering. Children's faces tend to light up at the mention of climbing a tree (when safe), making it easy to capture genuine, happy expressions. Crouch down and shoot up toward the subject, making the child appear more elevated than she actually is. Make playful faces or tell her to look for another sibling or something else in the park to help her forget the camera. For another terrific tree capture, have her sit or crouch in the notch of the tree and shoot up at her.

tip The fall hues of autumn sessions mean more layers of color and fun.

Captured in the shade after the sun had started to set, the light was even and the child's face easy to meter.

90mm F2.8 macro lens, f/3.2 for 1/250 sec., ISO 320

Photo by Rachel Devine Photography

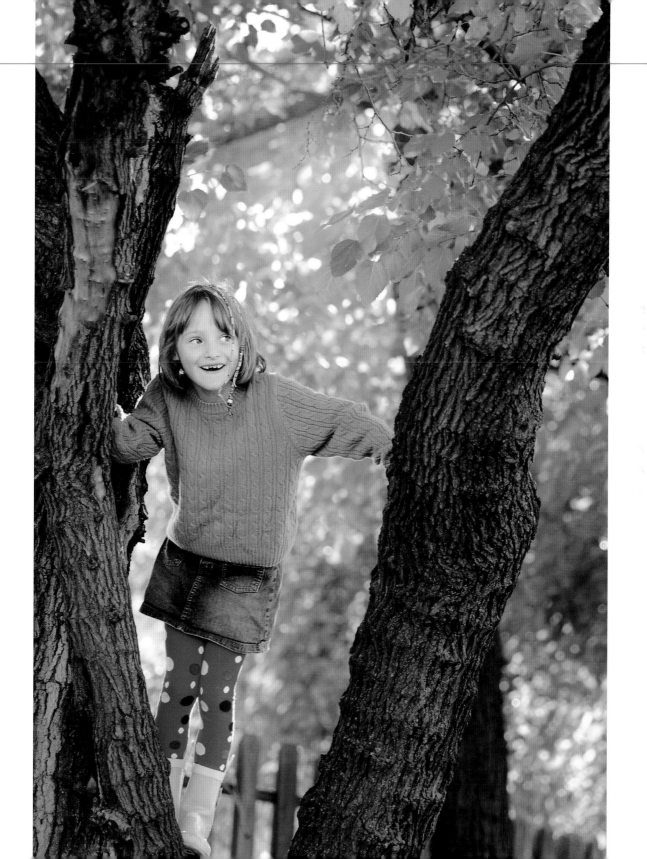

packing it in

Unusual items like suitcases in unexpected, potentially dirty areas create perfect portable perches for youngsters in seated poses. By renting or borrowing unusual items (this suitcase was rented from a local theater company), you can have an innovative shoot without the expense of buying (and storing) props. To get an adorable smile, playfully tease the model. Want another fun capture? Turn the subject and suitcase 180 degrees, and have her look over her shoulder. Grab a third picture by having her stand on the suitcase and jump off. Make sure the suitcase is sturdy first, and respect the rentals—they have your deposit, after all!

tip Mix and match accessories and patterns. Let kids pick out one of their own outfits to get them more invested in the session.

The light at this location is heavenly. With salt flats as the background, the white surroundings reflect light everywhere.
50mm lens, f/2.8 for 1/250 sec., ISO 200
Photo by Blue Lily Photography

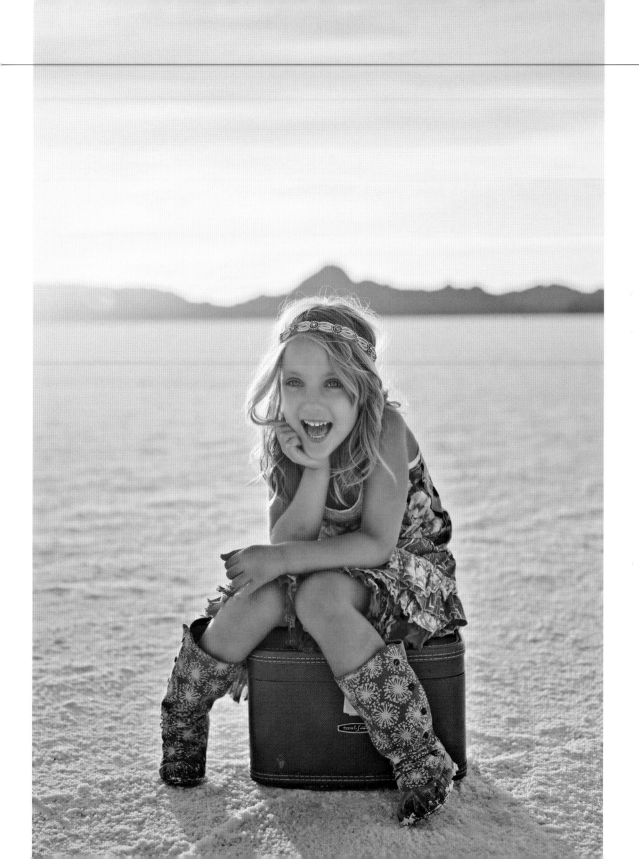

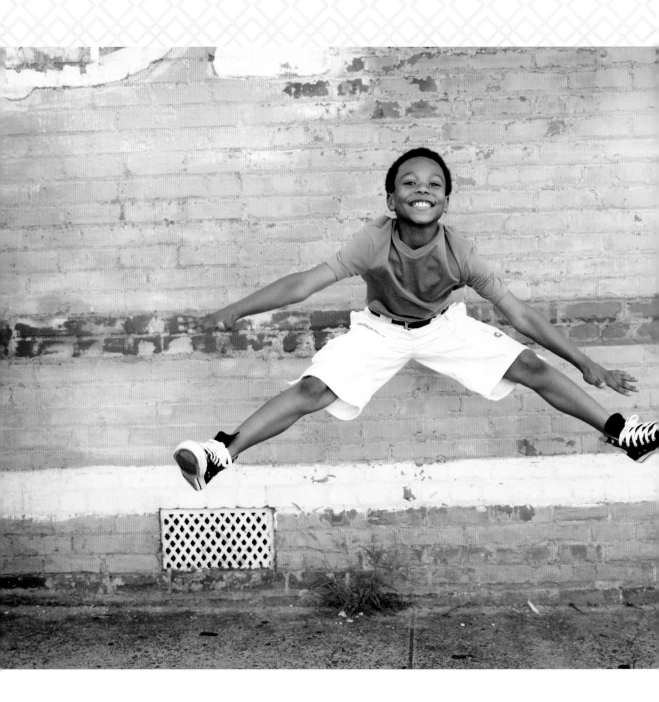

jump to it

If your subject is an athlete with talent and energy to spare, it's important to capture the magic—if you can keep up with him. Sometimes the hardest part is getting him to smile and look at the camera while also doing a toe touch—all without sticking out a tongue from the concerted effort. Be sure to show patience and a positive attitude; jumping shots are not only good sellers but are perfect for a story-board series: the first shot of the subject's anticipation as you announce, "On three . . . ," followed by a shot every second (with a cute face at every stage). When he lands, he's happy, too, because he's performed a cool feat.

tip **Be sure to use a fast shutter speed for images that are pin-sharp and not blurry.**

Open shade places the subject out of the sun but facing incoming light.
35mm F1.4 lens, f/2 for 1/500 sec., ISO 160
Photo by Whitebox

a turn for the better

As a personal challenge, add variety and explore new angles and directions in your sessions. A pretty young girl's portrait shot looking at the lens is a darling capture, but the image becomes more dynamic with her head turned away from the camera. Simply ask your subject to look at a certain focal point (such as a tree or flower) for a natural head position, rather than saying, "Turn your head like this." For a nice variation, ask her to crouch down a bit so that she is peeking over the grass, and zoom in a bit tighter.

> tip To make subjects glow, have them block your light source, as the girl in this portrait does with a setting sun.

Beautiful backlight softly frames this girl in an ethereal field.
80mm lens, f/2 for 1/250 sec., ISO 200
Photo by Jose Villa

little boy blew

The most successful props in images are connected to the subject in some way, especially when they are items the child truly enjoys. Musical instruments are no exception. Choose an instrument that is either one the child already plays or one that shares his personality, musical potential, or family history. Here, the trumpet symbolizes an important stage in this child's life as a young musician. Save prop shots for close to the end of the session to keep items pristine. For a second capture, find a cool tree, place the subject in the branches, and shoot upward to make him appear even taller.

tip A busy shirt can easily overwhelm an image. When clothing is out of place or too visually loud, converting the image into a warm black and white is a great solution.

 On this sunny day, the light was in front of and slightly to camera right, backlighting the subject. The photographer exposed for the shadows, ensuring that there would be enough light.

80mm Zeiss lens, 20 Ilford XP2 400 film (black-and-white film using color C41 processing), f/2 for 1/60 sec., ISO 400

Photo by Elizabeth Messina Photography

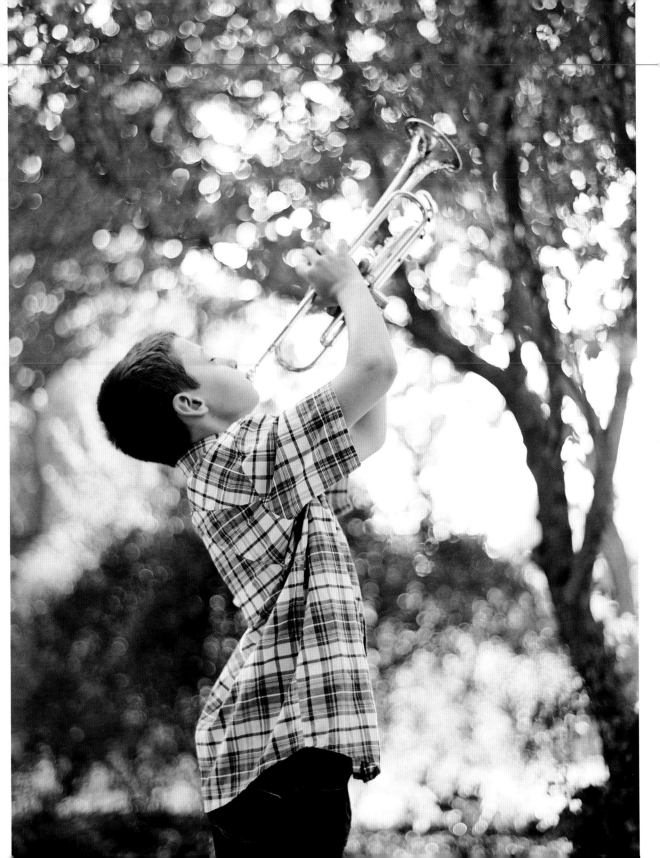

the eyes have it

Large, soulful eyes steal the scene in this dramatically lit black-and-white portrait. Have the subject sit and clasp his hands together for a chin rest. To highlight amazing facial features, go smile-free and shoot for a serious look. Here's another pose to capture in the blink of an eye: Have him sit backward on a chair for a stylish full-body or half-body portrait.

tip Want great eye captures for younger children? Ask tots to look at the shutter and lens and try to catch the camera's "blink."

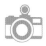

Natural light streams through an open garage door, and the subject is placed at a 90-degree angle to the light source, creating dramatic shadowing.
105mm macro lens, f/4 for 1/400 sec., ISO 250
Photo by Lisa Roberts

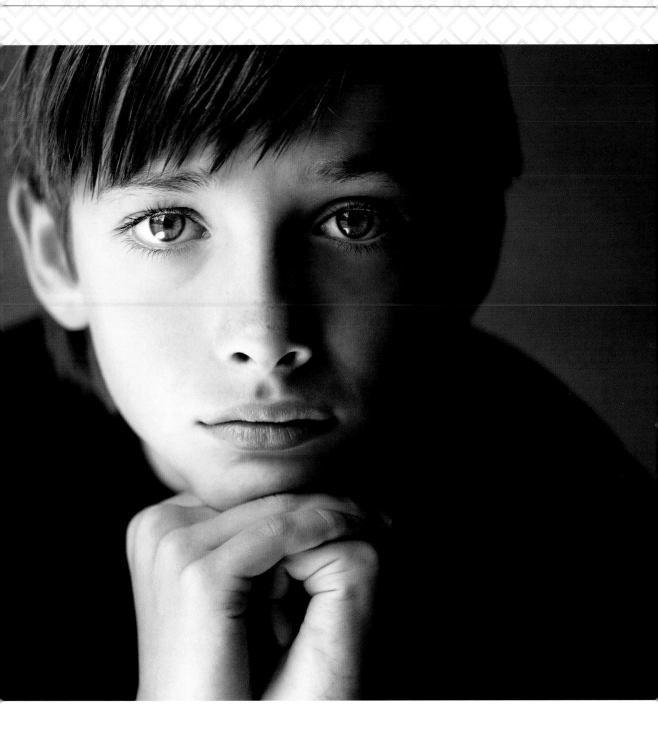

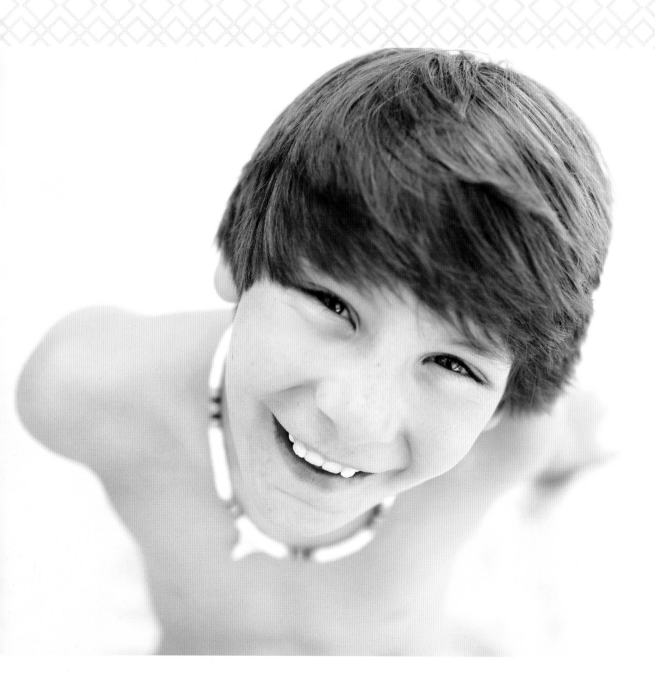

beach comber

This boy's great hair and a favorite necklace capture his character, while a shallow depth of field keeps our focus on his eyes. For this creative wide-angle portrait, have the subject sit on a beach or the ground and lean back on his arms. Stand above and ask him to swing his head slightly as if to get his hair out of his eyes. For another cool, casual capture, have him flip onto his belly, resting on his elbows and propping his chin on his hands.

tip While not every shot in a beach session should be shirtless, it works to pose a boy without a top for a few pictures, especially if he's a sporty beach kid.

Putting the sun behind this boy on a bright day in mid-afternoon creates incredible backlight.
35mm F1.4 lens, f/2.5 for 1/640 sec., ISO 160
Photo by Whitebox

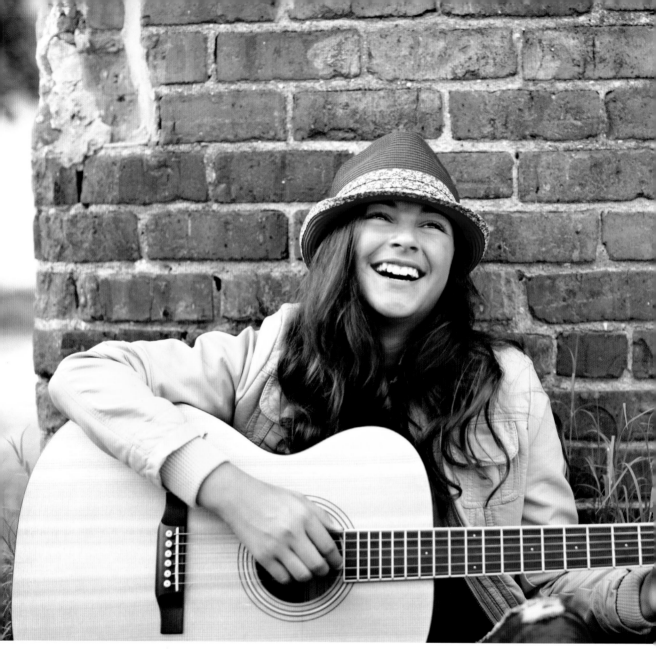

 Like the vibe, the light in this alley is pretty cool, so contrast and saturation were bumped slightly and the image was warmed up in postprocessing.

50mm F1.2 lens, f/2 for 1/250 sec., ISO 160

Photo by Whitebox

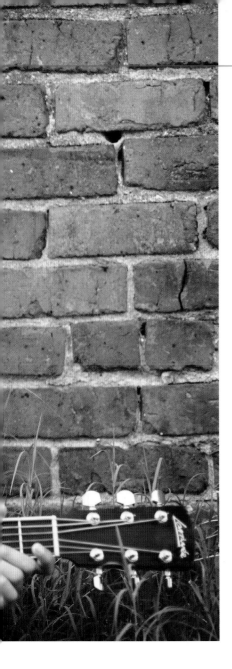

music
to our eyes

Older kids sometimes become ever so slightly self-conscious during a session. Musical instruments can stave off those potentially awkward moments, building up their self-confidence and raising energy levels. Here, the photographer places the musician against an old brick wall and asks her to start playing. "Now stop and give me your loudest laugh" is the prompt for this happy moment. For a cool second capture, find another old, textured wall, nearby if possible. Shooting from the side, have her lean against the structure and turn her head to look at the camera for a head shot or a closer crop of the upper body.

tip Tweens are typically focused on developing their own style, so to get them invested, let them choose wardrobe and some elements (such as surfboards, instruments, iPods, sports equipment) for a few shots. And always be on the lookout for great textures, like that weathered brick wall.

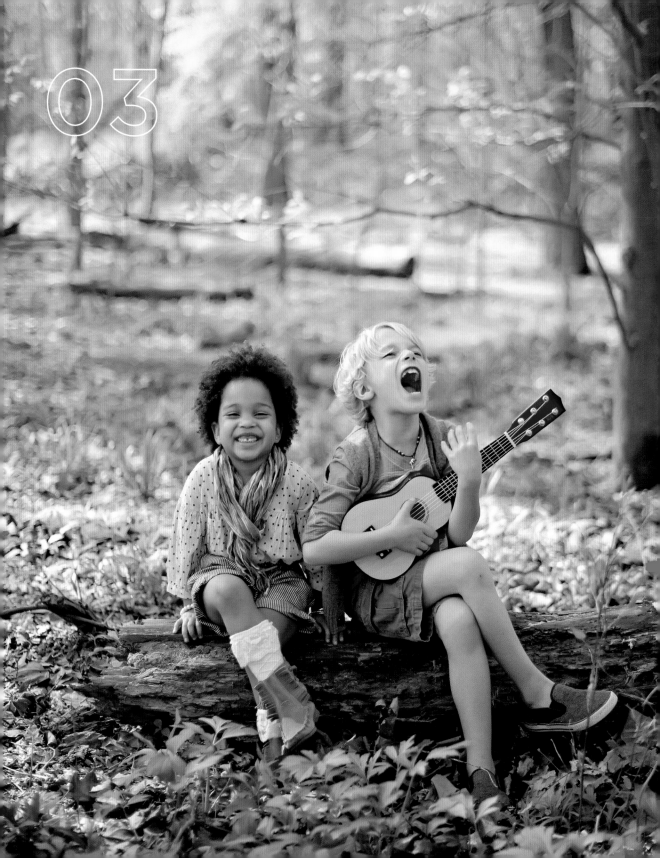

siblings

Whether they're blowing kisses or raspberries, rolling around in the grass, or chasing one another, relentless energy and love abounds from siblings.

Start with the sibling shots first, because kids are usually more cooperative at the beginning; then capture individual shots later, starting with the youngest kids.

To capture the bond between the siblings, encourage the kids to "squeeze" together when siblings are innately close. This may come naturally with some siblings and not with others. You might start by asking them to hold hands, and then say "One, two, three: hug!" to get them close together. This isn't about perfect positioning but about the love and fun you can capture. Many of the best shots are poses gone awry, when children fall out of a pose like this and laugh or do something silly. More than anything, parents want to see their children having fun together.

It can be difficult to get children aged four and under to stay together, especially outdoors. Find something to stabilize them—stairs, a chair, a fence—long enough to get a shot. Where sometimes being the oldest in a family is the least exciting, here older children win a starring role as the photographer's assistant.

Kids love to hear that they are doing well, so be lavish with genuine praise. Laugh and smile and show thetm that you enjoy their company. Ask for their ideas, and incorporate them whenever possible.

With a little encouragement from you, the resulting portraits will mirror fond memories of togetherness.

Photo by Michelle Huesgen, Untamed Heart Photography

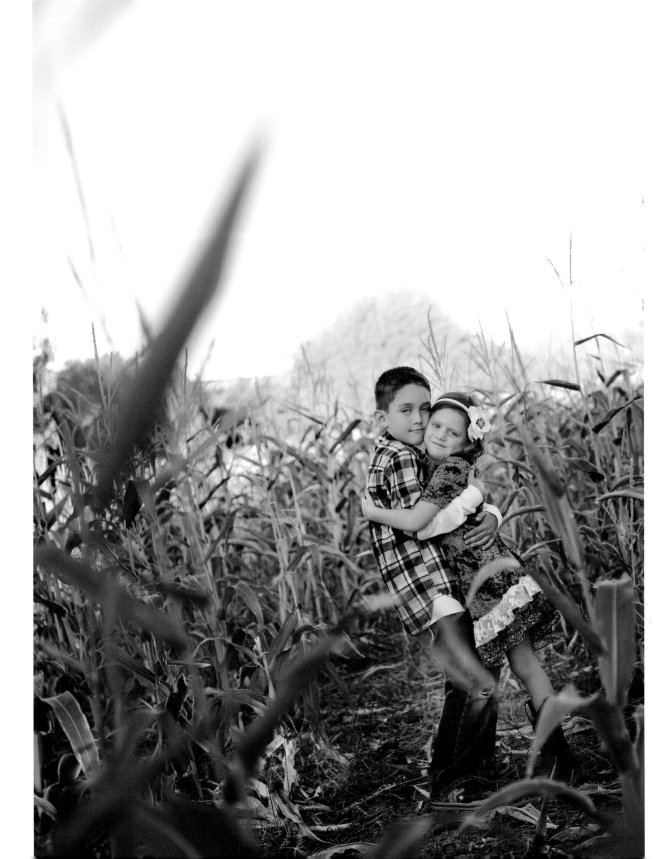

what a lift

When photographing younger children, regardless of the location, ask the older sibling to give the younger one a hug while they both look at the camera. In this image, a big brother lifts his younger sister off the ground. Be sure to position subjects for depth in the image, including vegetation in the front for added interest and a feeling of having just stumbled upon your subjects. For another capture, zoom in tight for the hug shot or have the kids peek out from behind trees, bushes, or cornstalks.

> tip Asking older children to pick up a younger sibling makes them feel mature and ensures tight contact without any awkward white space between the bodies.

 To ensure proper exposure for the subjects and cornfield, the photographer had to overexpose the late-afternoon, sun-filled sky.
24–70mm F2.8 lens, f/2.8 for 1/320 sec., ISO 200
Photo by Sandi Bradshaw Photography

best friends

Much hugging and kissing can ensue from a sister shoot. When sisters are particularly close, show this with their body language. Ask them to squeeze together as closely as possible and to put their arms around each other. Long, lanky legs appear less awkward when crossed at the knee or the ankle. The freshness and vibrancy of the sisters and their soft, flowing clothes also bring a modern moment of life to the otherwise formal, reserved landscape. For a second sweet shot, zoom in for a tighter composition of just their faces, leaving part of the kisser's face cropped slightly out of the image.

tip Group siblings as closely together as possible to avoid empty space between them, even if it feels closer than you think will work.

Natural backlight about two hours before sunset creates a beautiful scene.
100mm F1.4 lens, f/2.5 for 1/250 sec., ISO 400
Photo by Blue Lily Photography

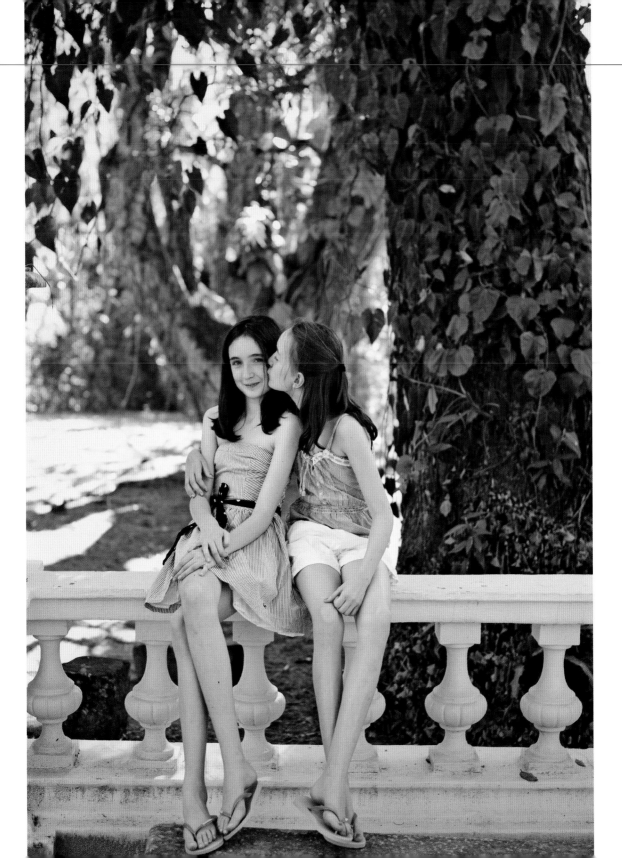

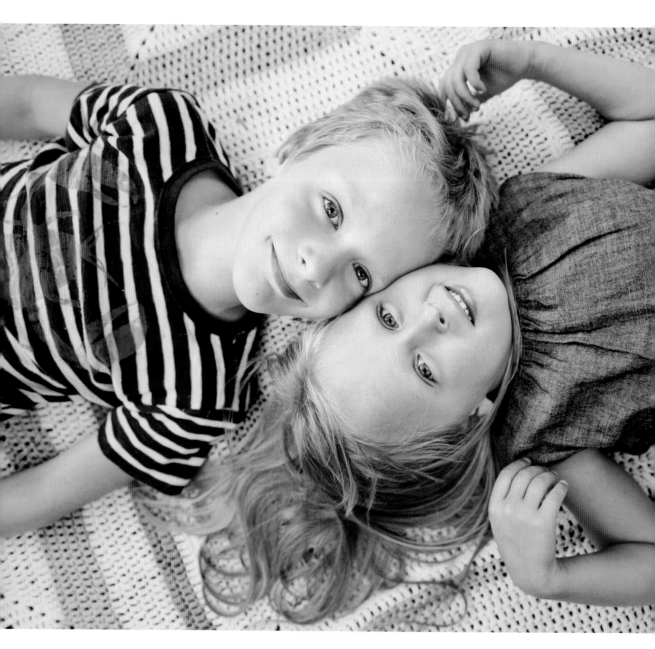

 For this image photographed in the open shade of a tree, light comes in from all directions, making a reflector unnecessary.
24–70mm F2.8 lens at 29mm, f/2.8 for 1/250 sec., ISO 500
Photo by Blue Lily Photography

cheek to cheek

Kids like to do unexpected things at photo shoots, like lying down, so this pose is a big hit. To bring out a relaxed, connected feel, ask them to lie down, and then patiently wait while staring at them. Even the rowdiest of children will eventually grow curious as to why the photographer is patiently staring at them. In that moment of genuine curiosity, when they turn their attention to the camera and let their guards down, is when authentic expressions make the pose come alive and are best captured. For another sweet shot, capture the siblings holding hands.

tip When doing outdoor sessions, keep a blanket on hand in case the grass is itchy or damp.

bench warmers

Benches can be surprising platforms for kids usually told to keep their feet on the ground. Ask one sibling to whisper something silly in the other's ear and capture their playful whispering, as well as the resulting big smile. For a third capture, ask the brother and sister to gently hug each other. If it's safe, jumping off of the bench might make for a fun final image.

tip For more interesting, unexpected portraits, let kids stand or sit on benches or low ledges when safe, always with a spotter nearby.

Soft sidelight creates a serene scene.
24–70mm lens, f/4 for 1/60 sec., ISO 800
Photo by Milou + Olin

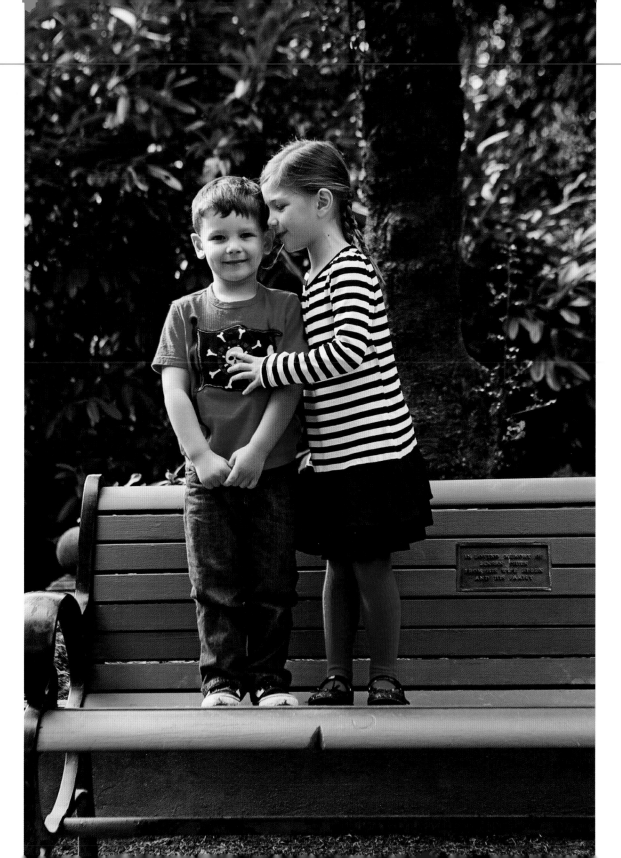

lip service

A backdrop of white blankets and pillows keeps the focus on your gorgeous subjects and nothing else, creating a dreamy scene. Dressing siblings in white or neutral-colored clothing ensures that their faces will be the most important parts of the image. Position the children first, and then ask the girls to give each other a sweet, gentle kiss (rough smooches can lead to someone falling or crying). For a terrific triptych, capture three shots: the lean in, the kiss, and the follow-up response to the event.

tip For more romantic, timeless images, choose light clothes and soft, neutral backdrops. Using sepia, black-and-white, and desaturated tones also lends to a timeless feel.

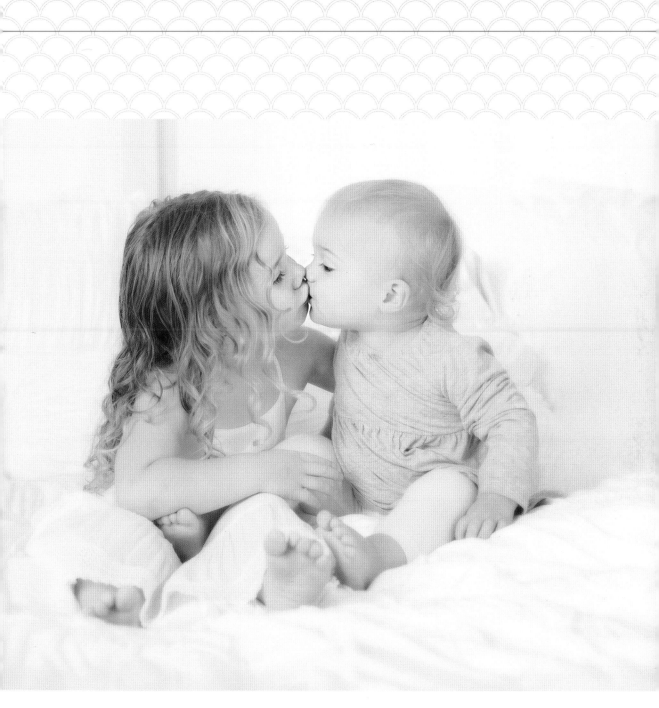

 Shot indoors on a dark, cloudy day, this image was lit with a strobe and large softbox.

28–75mm lens, f/3.2 for 1/200 sec., ISO 800

Photo by Mindy Harris

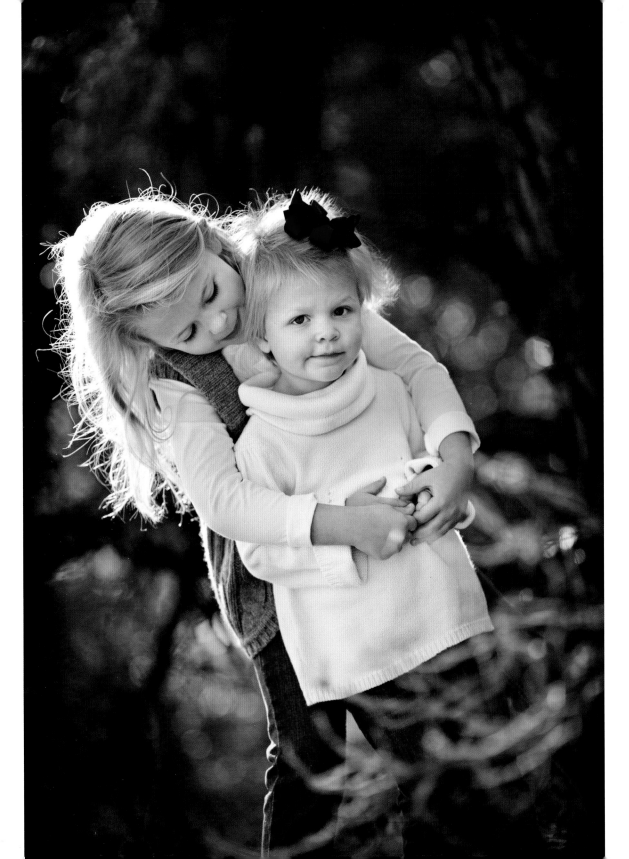

sweet & natural

Unexpected hugs are the best. In this appealing scene, both the hug from behind and the image's tilt are refreshingly different. One of the girls makes eye contact while the other doesn't, making the scene even more spontaneous and sweet. Play with depth of field, framing the scene with natural finds in the foreground and background. Grab a quick, zoomed-in horizontal shot for a different feel of the same sisterly connection.

tip If an image is too static, give the camera a little tilt. In addition, having something interesting in the foreground and background—even if not in focus—brings eyes to the middle.

Backlighting creates luscious rim light on the sisters' blonde hair, while a reflector bounces light back onto their faces.
135mm F2.0 lens, f/2.2 for 1/800 sec., ISO 250
Photo by little nest portraits

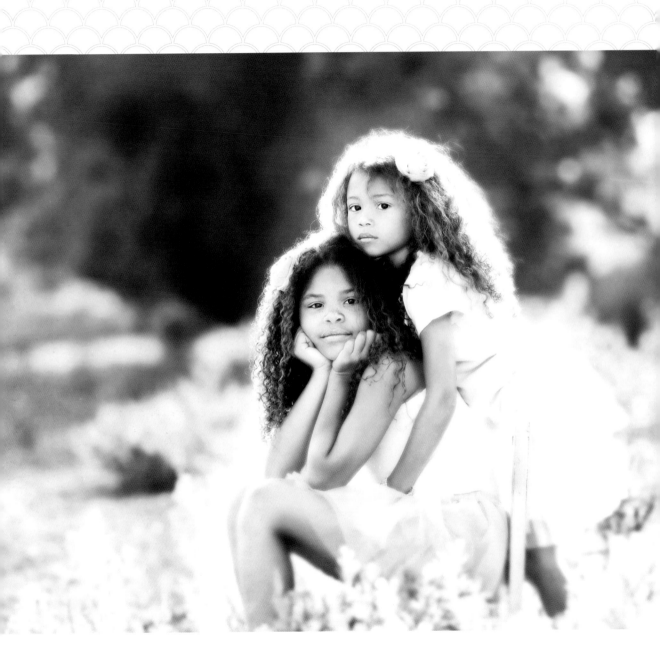

togetherness

In another great pose for two siblings, the oldest sits on a tiny chair (a prop perfect for impromptu scenes and one that fits into a car without much effort), while her sister leans against her. Pose the older sister on the chair first; then move the younger one in for a great connection. Make sure subjects are close, and ask them to look at the camera without any big smiles. Afterward, tighten up for a gorgeous face shot.

tip When sibling clothing choices (specifically complex patterns or colors) threaten to compete with the photograph, cropping and then converting the image to black and white creates a more timeless image and more opportunities for a portrait that will fit almost anywhere in the home.

A bright sun is low enough to provide glorious backlighting but high enough to avoid haze, with the subjects positioned for maximum glow.

135mm F2.0 lens, f/2.8 for 1/800 sec., ISO 200

Photo by Mindy Harris

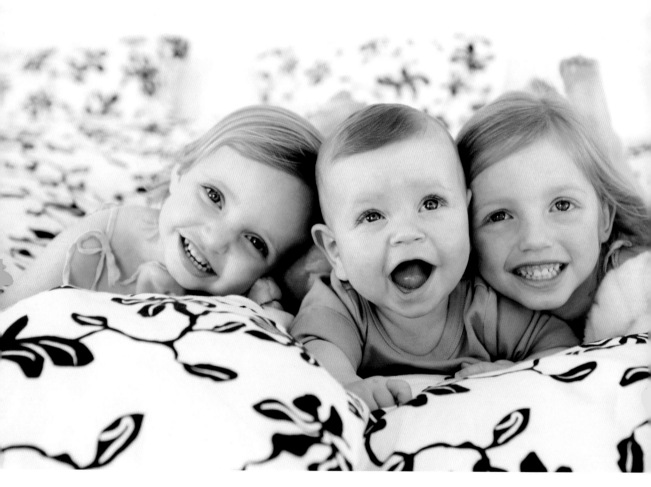

A large window behind the photographer allows morning light to pour in over the siblings.
24–70mm F2.8 lens, f/3.5 for 1/125 sec., ISO 400
Photo by Lena Hyde Photography

smiles wide open

Any safe surface, or even the ground, will do for this pose, though the pattern of this bed's duvet is too delicious to pass up, especially when paired with the kids' contrasting, bright clothing. Show the kids how to lie on the bed by demonstrating if necessary (it is fun for kids to copy adults and see those same adults pretending to be kids), sandwiching little ones between bigger siblings to keep them safe. After you have the kids in position, shoot from the foot of the bed, right over the edge, making sure their heads line up close to the same plane of focus (keeping their eyes on the same level). Have mom stand behind the camera making silly faces and jumping around to get natural smiles. For an alternate picture, an adorable feet shot shows delightful sibling size differences.

tip If any of the siblings are really attached to a favorite stuffed animal, let them bring it to the beginning of the shoot for comfort.

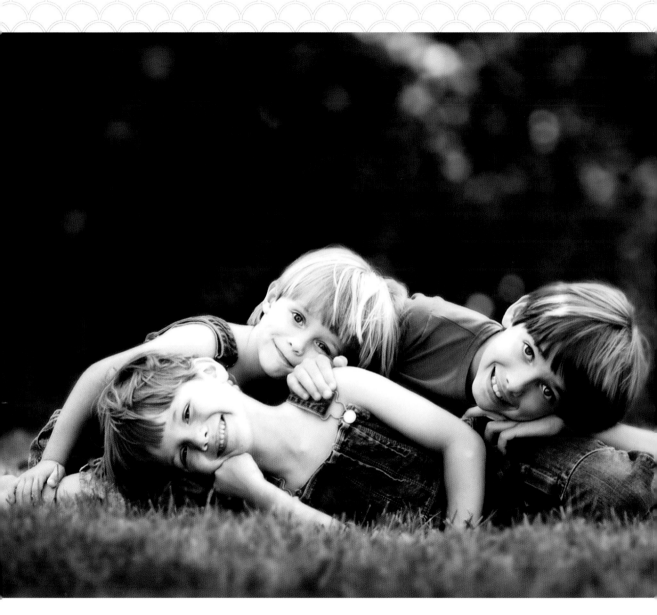

 Natural light from a large, open sky in front of the subjects and diffused backlight behind them creates a peaceful feeling.

200mm F2.0 lens, f/2 for 1/640 sec., ISO 200

Photo by Lisa Roberts

three-boy pileup

This fun formation is precious for kids able to follow direction and hold poses. While fairly tricky to accomplish and have look natural, the results are worth it. Have the siblings pile up on the ground comfortably, smiling, while looking as relaxed as possible. Line up all sets of eyes so they are in the same plane of focus. This black-and-white portrait is a stunner, because it shares just how alike these kids look in facial structure. For another great capture, have them stand up in height order or form a human pyramid on their knees (with a spotter just outside the frame).

tip Show the closeness and playfulness between siblings by encouraging them to "Cuddle in!" or "Squeeze into your neighbor!" This type of direction can create fun, candid moments for the camera.

step sisters

Any staircase—even an unexpected, dingy one like the one pictured here—makes for a surprisingly easy posing place. In this example, the gray helps the vibrant kids stand out and acts as an interesting backdrop. When working with three or more siblings, take a picture of the two oldest sitting side by side. Once the older girls are set, ask the younger siblings to join on a lower step, and ask the older ones to connect with each other by touching. Whether everyone is on the same step or in different combinations, having everyone touching leads the viewer's eye around the composition and creates a nice connection within the image. Falling is a potential safety issue, so keep little ones near the bottom and have a parent standing by.

tip Ask older children to model good behavior and set a positive example for their younger siblings.

Diffused bright sunlight from a beach in front of the group lets the girls shine.
28–70mm F2.8 lens, f/5.0 for 1/60 sec., ISO 800
Photo by Lena Hyde Photography

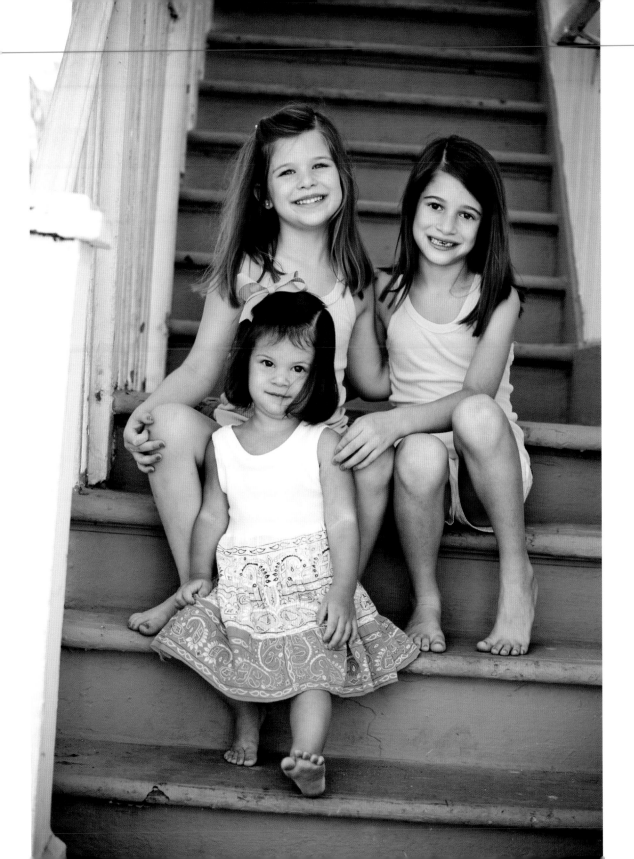

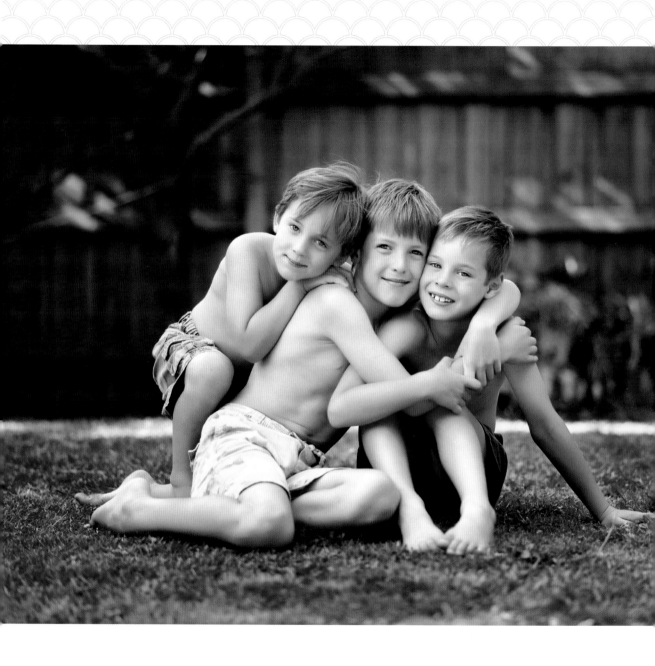

bond of brothers

A deliberate lack of extra elements makes this image work, as not even T-shirts or shoes take away from the subjects. Because these brothers are all very close, both in age and relationship, the photographer encouraged physical closeness to emphasize their connection. When brothers play naturally, there is typically physicality and roughhousing, so a hug is a natural progression without looking like a pose. Have the two older boys sit together, and ask the younger one to join in, keeping faces close together and arms intertwined. For a second capture, get the brothers playing prior to the hug, or catch them falling apart afterward.

tip With more than two kids, while it might seem obvious to pile kids in simultaneously and hope for the best, it's best to pose the first child, then the second, and then the third.

In the open shade of this big backyard, bright, dappled sun shimmers lightly through the trees.
105mm F2.0 lens, f/2 for 1/1250 sec., ISO 250
Photo by Rachel Devine Photography

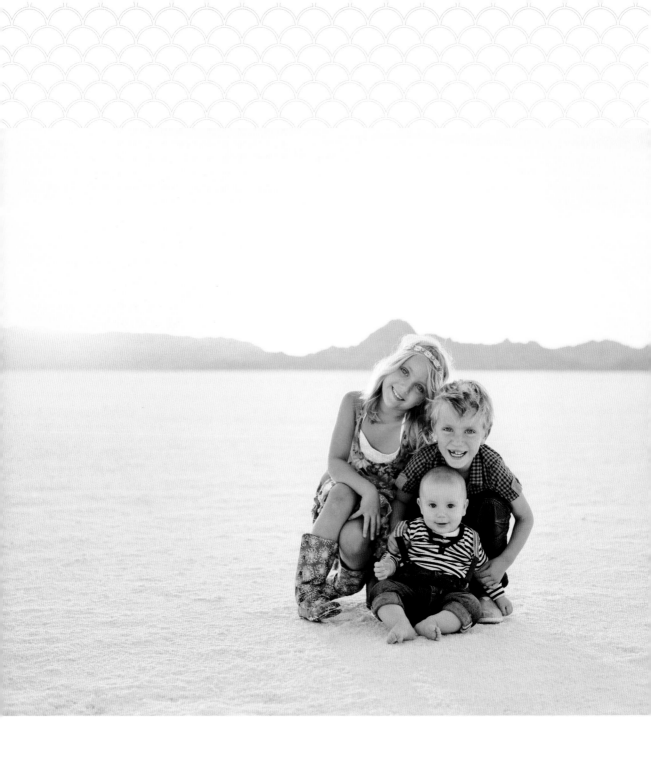

cuddle huddle

Three or more kids and a wide open space can provide acres of fun and allow for intimate scenes among siblings. After ensuring the ground is cool and debris-free, place the baby with his brother behind, supporting him. Add a leaning sister, for an image in which all siblings are doing something slightly different but still showing connectedness. Notice how their hands are engaged with one another in the shot. For a second capture, get the two boys together.

tip Wee ones will always need a helping hand. Ask older children to take care of their baby siblings, adding to the family experience.

The bonus of a reflective surface, such as sand, is that it bounces light, as with these subjects in shadow and lit only by the indirect sun reflected by sand at dusk.
50mm F1.2 lens, f/2.8 for 1/500 sec., ISO 200
Photo by Blue Lily Photography

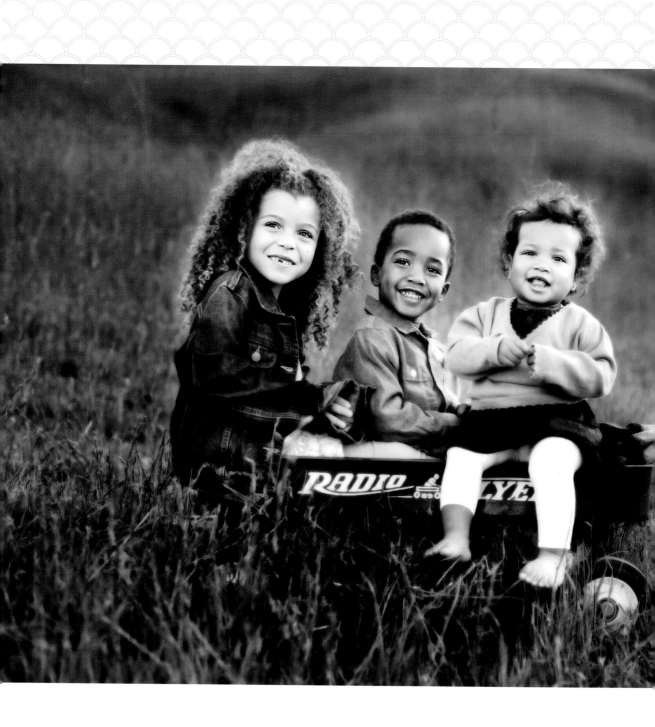

hitch your wagon

The wagon is a perfect symbol of childhood (and helps contain little ones prone to flight). These three siblings are seated in order of age with the youngest sitting on the end, as she is the most likely to resist being restrained for long. For more images, change the angles and use combinations of the kids sitting, standing, or even pulling one another in the wagon—though take care not to overuse this (or any) prop. In this case, a black-and-white conversion helps minimize the prop, keeping the kids as the center of attention.

tip In an environmental shot in which the image might be overwhelmed by scenery, convert the picture to black and white to help your subjects stand out even more.

Soft light, diffused by a giant hill, is easy to work with and gives a soft glow to hair.

50mm lens, f/1.4 for 1/640 sec., ISO 800

Photo by Mindy Harris

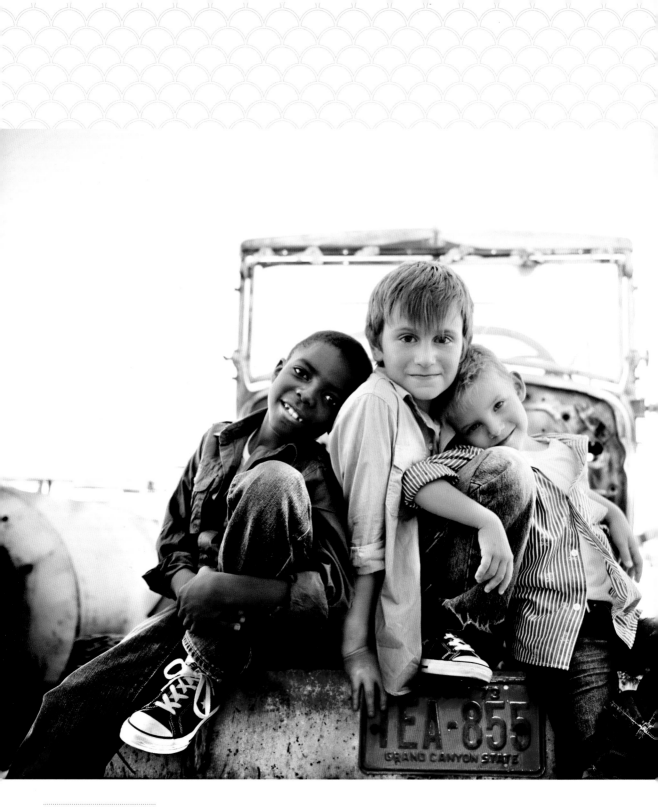

fender loving care

Boys naturally gravitate toward cars, making vehicles great for guy poses. In this instance, a junkyard provides some rustic (if not rusted) places for these cool dudes to show their boyish bonds. Use caution in locations with broken, scattered items, and talk to your subjects about sitting still and staying right where positioned. Focus on their closeness while keeping everyone relaxed and comfortable. Get that boyish charm by seating your young subjects in poses they tend to adopt naturally, overlapping their bodies and leaning on one another. For posterity, grab another tight shot with three faces cheek to cheek.

tip If a session is in a potentially hazardous location, make sure to get parental permission. Shooting will create a distraction, so choosing a parent as a safety assistant is extremely important.

This delightful image was shot in open shade about an hour before sundown.
24–70mm F2.8 lens, f/2.8 for 1/320 sec., ISO 200
Photo by Sandi Bradshaw Photography

three's company

Because pictures of twins often show them together as a unit, why not separate them for a change? Mix it up and move kids around. Get big brother to put his arm around his sister, while the other sibling sits in the chair for an unexpected, fresh take. To keep energy levels high, use a finger puppet "assistant" while taking the shot. Utilizing different chair heights for subsequent images can take kids to new levels of enjoyment within the frame.

tip Take your lead from the kids you're photographing. Unless they're an affectionate bunch by nature, getting them to cuddle together in an embrace will often look awkward. You can encourage connection through play or by placing siblings together within the frame without the entwined limbs.

Even with windows to camera right, a bump in the ISO was needed to lighten this relatively dark room.
24–70mm F2.8 lens, f/3.5 for 1/60 sec., ISO 800
Photo by Lena Hyde Photography

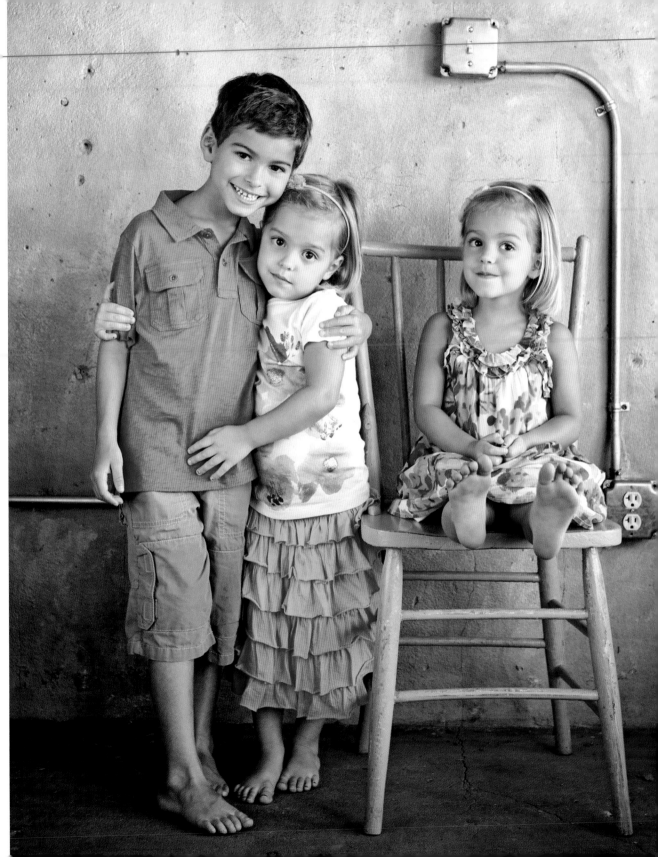

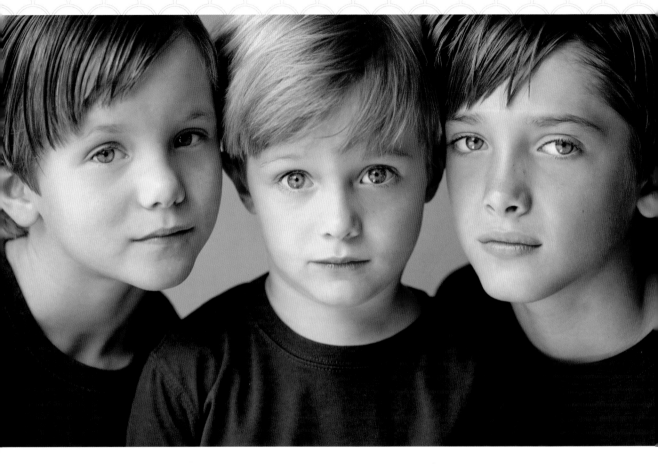

 Lit only by natural light in a garage, the subjects were placed 45 degrees from the open garage door (light source) for effective shadows on their faces.

105mm macro lens, f/4 for 1/400 sec., ISO 400

Photo by Lisa Roberts

up close & personal

Brothers look both serious and sweet in this powerful portrait. Seat siblings close, and ask them to lean in and bring their heads as close together as possible while making serious faces. The fact that the eyes are lined up keeps the shorter, younger brother on an even level with his brothers. For more captures, have the siblings stand, shoeless, and hold hands, with the youngest in the middle; or have them intertwined, arms around one another or elbows linked.

tip If you have space or budget for only one paper or fabric background, make it a neutral mid-range or dove gray for flexible shots in almost any situation. The paper will appear darker or lighter depending on the lighting.

superkids

Look out, villains opposed to exciting poses! Even when not dressed up, kids like superheroes, so let their imaginations run wild. Line up the siblings and ask them to strike their best superhero poses. Encourage kids to "make muscles," and showcase their superhero mannerisms. Grandiose, fun gestures and over-the-top, exaggerated comic book poses work wonderfully for madcap captures that show personalities at play. Have older siblings lift up a younger sister or brother between them for more fun.

tip Avoid making styling a key focus of your shoots. While styled shots are cute, even simple elements, such as the capes here, will net heroic results.

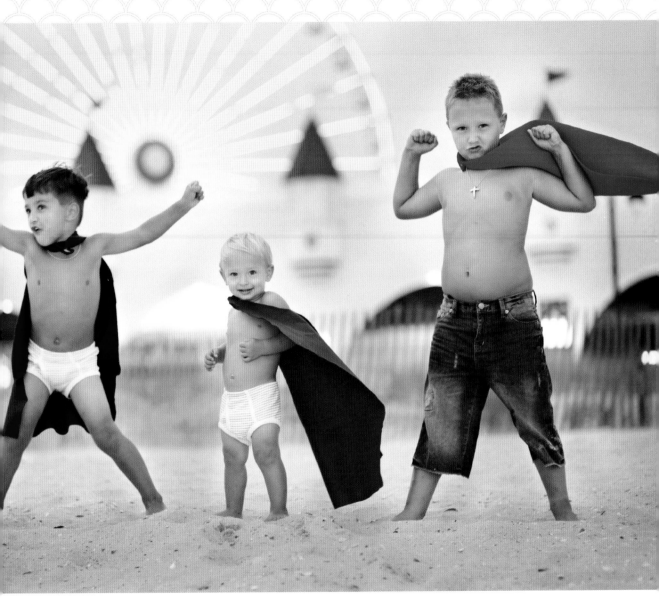

 Captured as storm clouds rolled in, this image was saved by a high ISO.

85mm F1.2 lens, f/2 for 1/200 sec., ISO 1000

Photo by Whitebox

everyone needs
structure

In a setting with an architectural element, like this simple fence, look for a variety of ways to use it. Here, a wide-angle shot paired with a distant vanishing point allows the fences to draw the eye to the children, but you can use other types of structures to corral kids visually. First capture shots of siblings posing together in front of the structure. After a few pictures, let your minimodels interact with the scenery for some added opportunities, as seen in this example. Go in for vertical head shots of each child, or have them peek through (or around) the structure—or lean against it—for even more diversity.

tip Be sure to look for splinters and loose rails when working with fences or other aged, exposed surfaces, and always ask permission before shooting on private property.

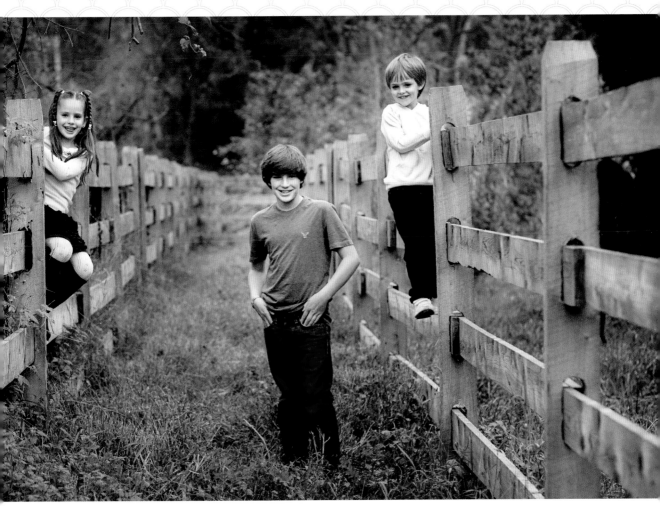

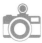
Taken in open shade at dusk, this portrait has comfortable, even light.
85mm F1.2 lens, f/4 for 1/200 sec., ISO 640
Photo by little nest portraits

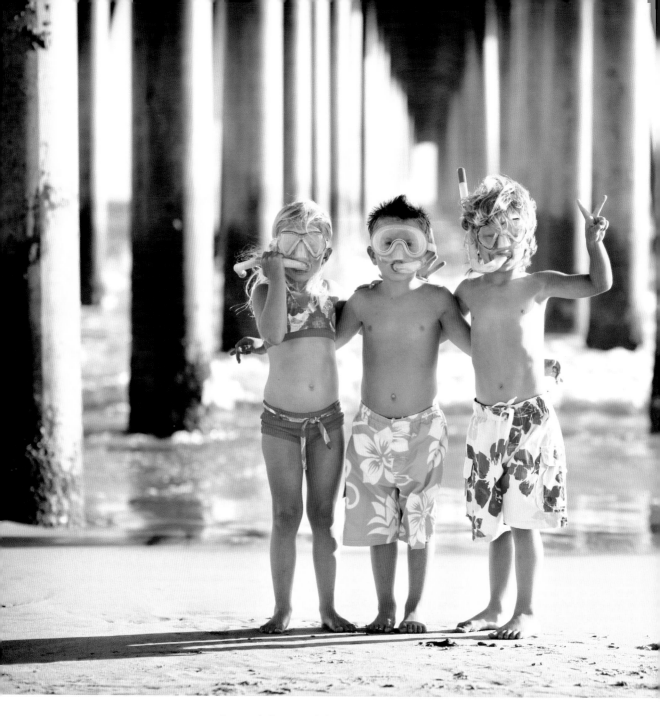

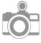
Soft, sunset lighting conditions bring an ethereal glow to this portrait.
85mm F1.2 lens, f/2.5 for 1/1600 sec., ISO 100
Photo by Shannon Sewell

giving props charm

Nothing says summer like a trio of terrific tots ready for adventure. Props (in this case, snorkels) and a sense of fun can turn a beach shoot into precious playtime. To make the most of childhood spontaneity, ask the siblings to huddle together, and watch their personalities emerge. Here, the little boy on the end throws up the peace sign on his own. For another terrific portrait, have the kids make a "hug sandwich" while looking at you.

tip Beaches are amazing locations, but they are also rife with reflective glare, so be on the lookout for shade (and bring sunscreen).

sweet seat

An oversize, slip-covered chair serves as a perfect spot for containing young siblings. Ask mom to have unsure siblings practice holding their baby sister or brother (or a doll) before the shoot to get them at ease. An overstuffed ottoman right at the foot of the chair will provide a safeguard in the event of the baby rolling. Start by placing the older children in the chair, and explain how they will hold their sleepy little sister or brother together; then ask mom or dad to carefully position the baby. Sing a favorite, age-appropriate song, and watch the older kids light up with big smiles. Kneel on the ottoman to snap this shot. For another great grab, take a picture of the two older subjects looking at the baby.

tip Little kids are hard to corral, so a natural container is useful to keep them closer together. In this portrait, a chair with high sides and a baby in the lap keeps the two more restless siblings in place.

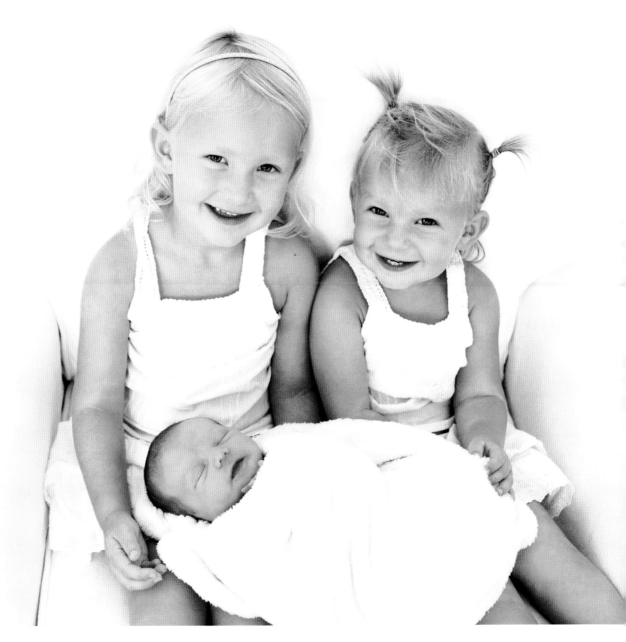

 Natural light is flattering for everyone, especially newborns, so always shoot in the brightest rooms of your client's house. Here, the window light is behind the photographer.

24–70 mm F2.8 lens, f/5.6 for 1/1000 sec., ISO 1600

Photo by Lena Hyde Photography

a little cheek

Playing a game like Simon Says can get a group of siblings in the groove and create a situation full of silliness and closeness. Prompt the kids to hug or kiss one another. Using a controlled game allows for happy and hilarious moments while still keeping you, as the photographer, in control of the situation. Here, big sisters are instructed to sweetly touch or kiss their little brothers on the cheek. For another terrific portrait, capture the group holding hands and moving toward the camera walking, skipping, or running.

tip Look for naturally occurring diagonal lines, such as the receding rows of trees shown here, to lead the viewer's eye to your subject.

Natural light about two hours before sunset on a cloudy day shrouds this magical scene.
24–70mm F2.8 lens, f/2.8 for 1/60 sec., ISO 1250
Photo by Blue Lily Photography

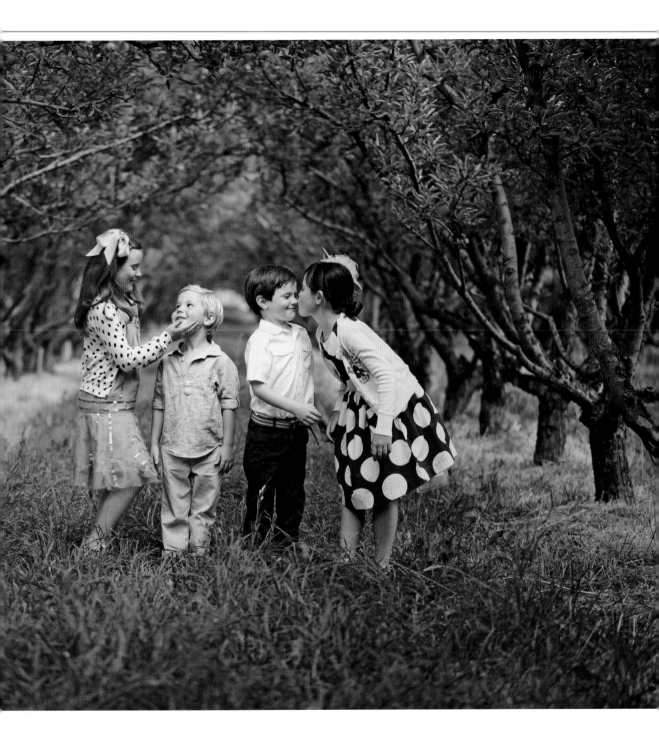

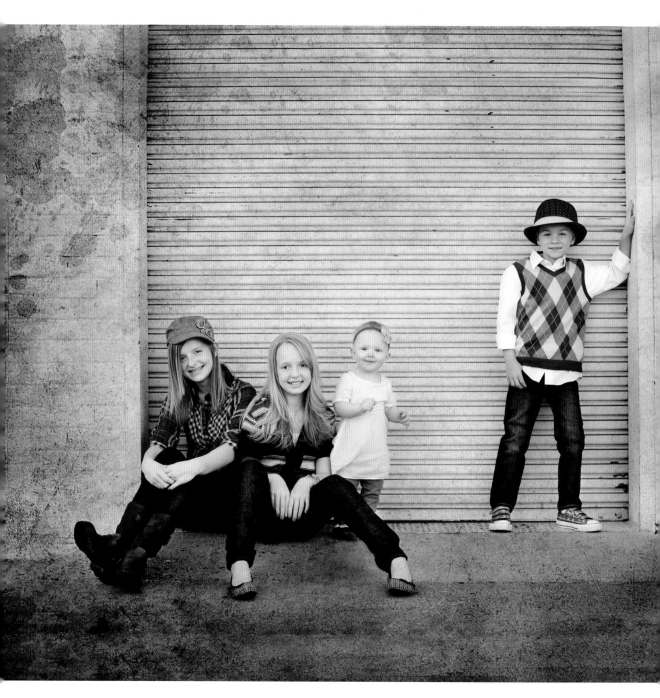

 This image was captured before sundown in open shade.

50mm F1.4 lens, f/2.5 for 1/500 sec., ISO 200

Photo by Sandi Bradshaw Photography

urban cool cats

While it feels normal to place siblings together, an unexpected, refreshing take on the group shot is to offset one of the siblings to the side. Here, the photographer places the older brother slightly to the right of his sisters. When working with subjects of varying ages, position the oldest subjects first, and then place the youngest within the setup. In this image, the three oldest were placed, and then mom safely situated the baby girl in the frame. This allowed the photographer to get (and keep) the older kids' attention without losing the attention of the little ones. For another grab, take pictures of brothers together and then one of the sisters. The older brother can also hold the little one for an unexpected, dapper shot.

> tip Create a system for keeping track of various types of locations that you might want to incorporate into future sessions, with either an app on your smartphone or another note-taking method.

four for all

Look for natural relationships between kids, putting them closer together when it makes sense. Because of the closeness of the cousins in this pose, they are naturally giggly. Get the girls to snuggle in close, and don't crop too tightly. For singularly superb grabs, snap an individual of each kid, even if a little of each of the other children shows up on each side.

tip Staring contests are a fun way to elicit smiles with little effort. Nothing brings on funny faces like having kids staring into each others' eyes. Sure, they'll try to keep a straight face, but they'll cave in to laughter soon enough.

Natural light and open shade make this picture even more sumptuous.
18–50mm F1.4 lens, f/5.6 for 1/200 sec., ISO 400
Photo by Anna Kuperberg Photography

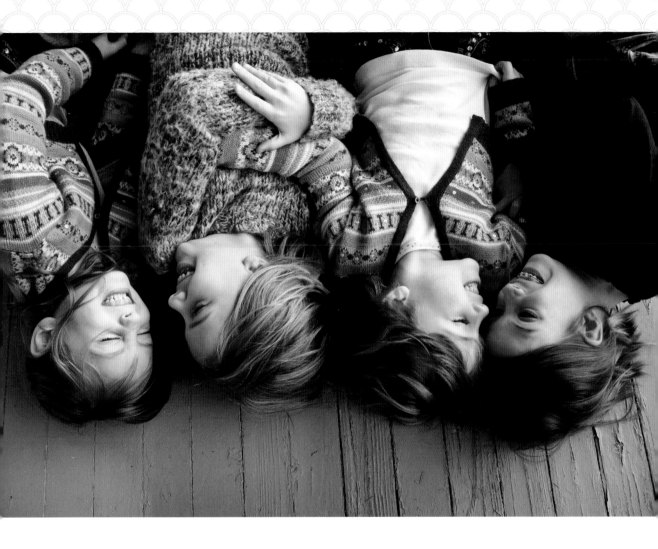

hop to it

Niches and fun doorways work well to contain a group. A great example is this fun, bright doorway that begged to be included during a downtown shoot. First, take a portrait of the kids standing together. Next, take one of them getting ready to jump. Finally, snap the midair jump. Demonstrate what to do and they'll be onboard for liftoff, following a 3-2-1 countdown. This shot can only be tried twice before kids tend to get bored, so be sure to set up and get ready to nail the shot the first time.

tip Support local vendors, especially when they play a part in your sessions, either by use as a backdrop or for props. At this confectionery, candy necklaces were a purchase not only for sweet treats but to ensure a welcome back for more pictures in the future.

Even though these siblings were facing east in the late afternoon, with the sun behind the building, it was still bright outside.
28–70 mm F2.4 lens, f/5.0 for 1/640 sec., ISO 800
Photo by Lena Hyde Photography

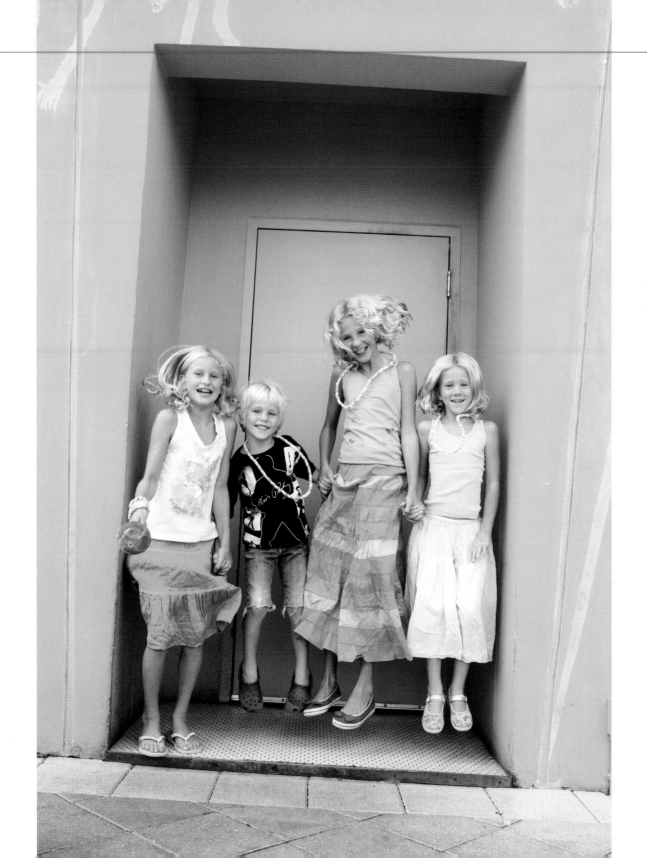

put your heads
together

A pose like this, which requires you to straddle some of the kids' legs, is best left for the end of the session, after you have built trust and friendship and the kids are comfortable. Here, six siblings (including a set of triplets) position their heads in the center. Have the kids close their eyes for a minute; then say, "Three . . . two . . . one— eyes open!" To nudge those natural smiles, tell jokes and ask questions like "Who is the messiest sister?" Prompts like these will help the kids open up and share funny stories.

tip Encourage parents to dress the kids in an overall palette of three to four colors. Everyone's clothing should be slightly different, using varied yet complementary textures and combinations.

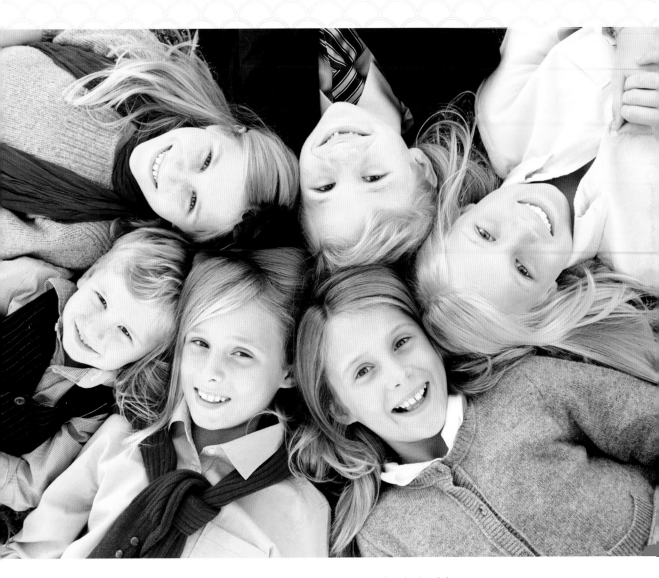

 Taken during the golden hour, in the shade of the house, this image has gentle, even lighting.

24–70mm F2.8 lens, f/4 for 1/125 sec., ISO 400

Photo by Lena Hyde Photography

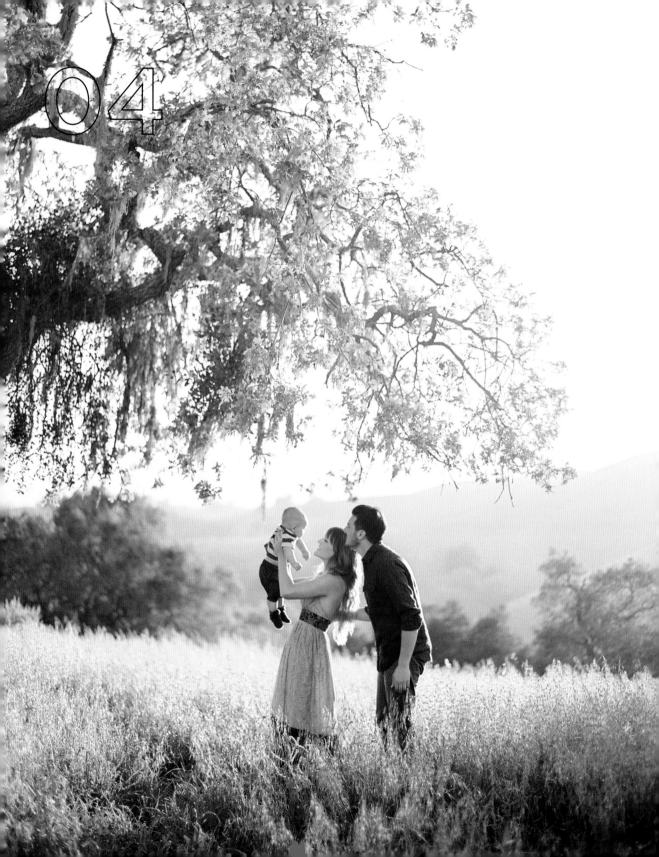

04

families

Taking a family photo is not for the faint of heart. This dynamic group can prove difficult to control and even more difficult to capture in a perfect portrait. Whether it's awkward hand positioning or clashing nap times, what can go wrong often will. Thankfully, solutions abound.

Square up your vision before the session. As the photographer, be sure to prepare clients for a successful shoot. Ask the family to stick to a clothing palette of three or four flattering colors instead of jeans and white shirts or khakis and black turtlenecks, all of which are outdated in modern portraiture.

At the shoot, make sure to let happy events happen, and be prepared go with the flow. Since no two families are alike, no two sessions will be the same— but then, who wants to shoot the same thing over and over?

Position families in the best spots for the most flattering natural light and keep them from facing the sun to prevent squinting. Periodically check the LCD preview to ensure you're capturing the best expressions possible from every family member.

Throughout the shoot, provide plenty of time for breaks and horseplay, especially if the kids are younger. It's easy for them to quickly burn out. Set the camera down and play from time to time.

With continued practice, you will understand that photographing a family portrait is an exciting challenge and an ever-evolving process for bringing a dynamic group together for one perfect shot.

Photo by Jose Villa

on the move

Having a child show off a new skill, like riding a bike or bouncing a ball, can be a great idea. Riding toys are especially great props for busy little kids; a tricycle will keep a fast-moving youngster from zooming off into the sunset—at least for a few minutes. Be sure to inspect riding props for loose bolts, rust, or wobbly wheels. For another beautiful portrait, capture mom standing tall and looking at her son to demonstrate scale and the mother-child connection.

tip Ask your clients not to tell their children that a photographer is coming over. Instead, build excitement by sharing that someone fun is arriving to play. The photo shoot should be treated like a game for them rather than a "have-to."

This beautifully textured old barn serves as a fabulous background and helps shield the sun to provide warm, soft backlight.
50 mm F1.2 lens, f/2.2 for 1/200 sec., ISO 100
Photo by Whitebox

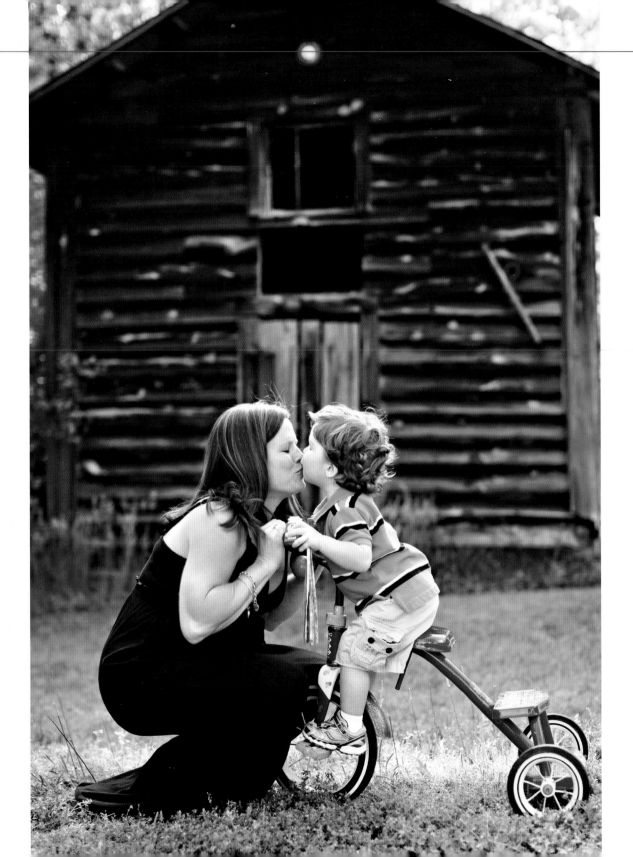

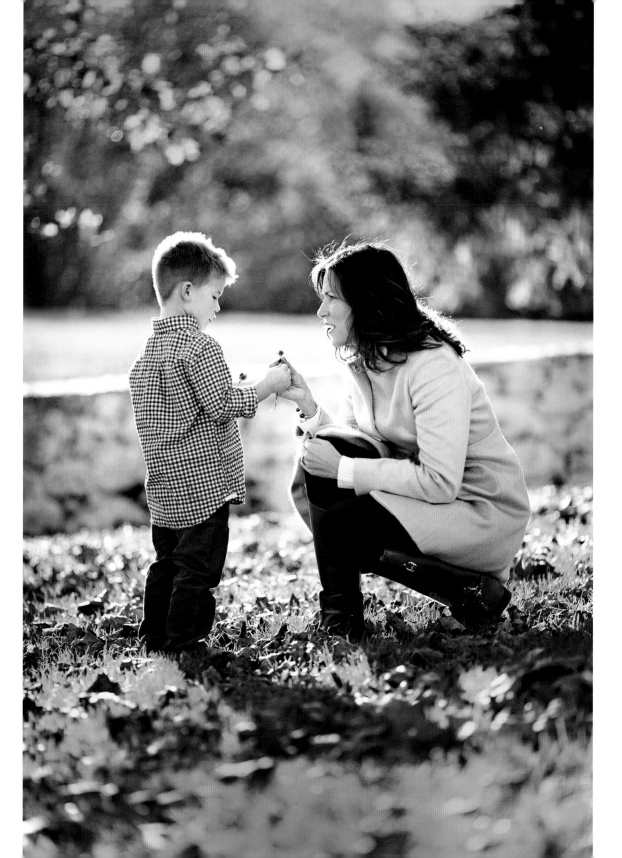

petal power

Successful images don't always require smiles and eye contact with the camera. Get people engaged with one another within their environment. All kids love flowers, and this intimate shot feels natural because mom and son are connecting without words. This is a moment every mother would love to have captured. Zoom in tightly on the child's clasped hands for a charming second portrait.

tip For a flattering look, place mom slightly in the background to make her appear more petite.

As the sun lowers on the horizon, mom and son are backlit while under a tree's shade.
135mm lens, f/2.8 for 1/3200 sec., ISO 500
Photo by little nest portraits

all in the family

When parents are less than enthused about being photographed, this pose is the perfect one to capture parental adoration while keeping the focus on the little one. Seat the parents on a blanket outside with their adorable child right in between them, making sure they are turned toward one another to portray a feeling of unity, not separation. For another sweet moment, pose mom and dad sharing a kiss or smiling cheek to cheek in a tight crop.

tip The technique of layering hands is great when kids are little, as it shares the differing sizes and textures of family members' hands. Beautifully wrinkled hands of grandparents mesh well with babies' chubby hands, too, and show connectedness between generations.

 This trio is bathed in early-evening light, the sun coming in from camera right.
50mm F1.4 lens, f/1.4 for 1/4000 sec., ISO 200
Photo by Michelle Huesgen, Untamed Heart Photography

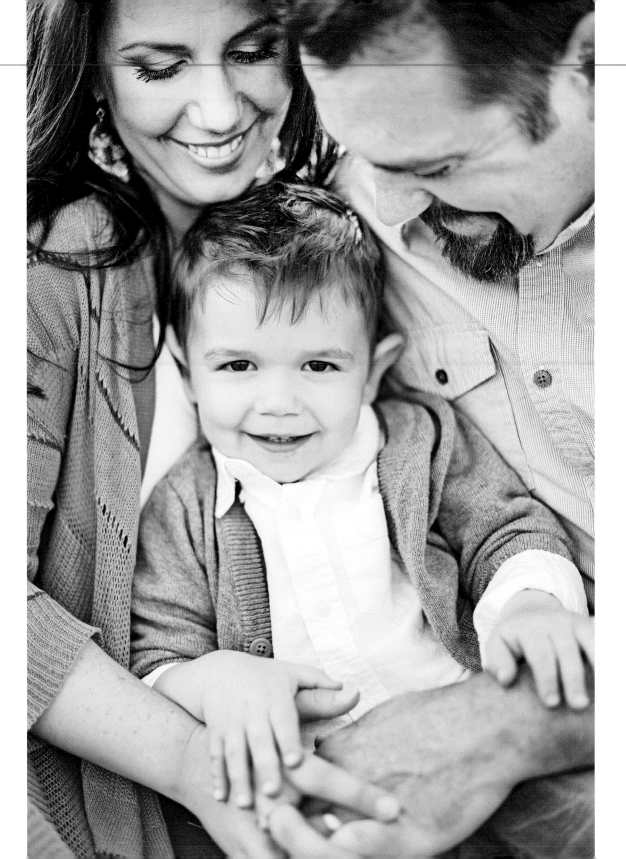

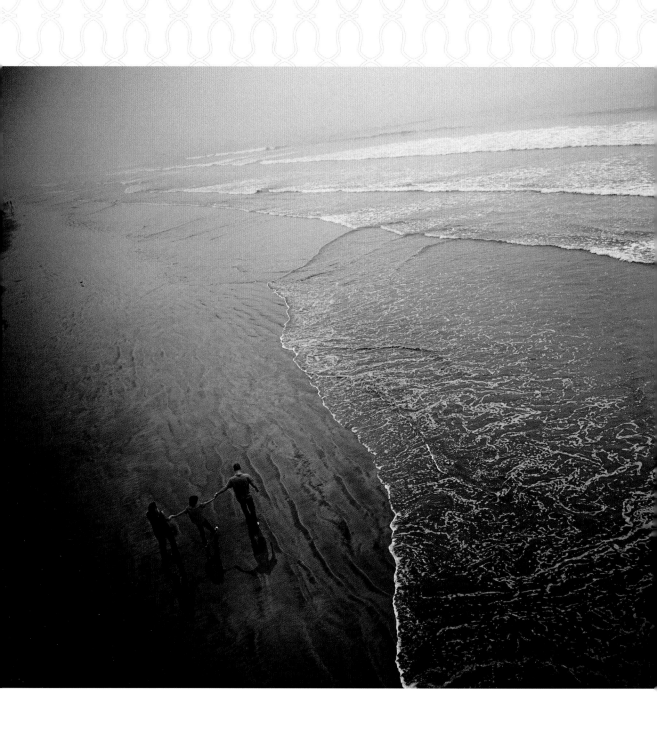

vantage
advantage

Environmental shots are a fantastic draw as a big piece of artwork and can be especially powerful when they don't feel posed. Here, a heavy fog at the beach makes for an unusually vacant scene. While this image was taken from the top of a pier, similarly stunning shots can be grabbed from any high vantage point where a photographer can view the family walking away. For a second portrait, have the family turn around and look up at the camera.

tip Asking subjects to interact with the landscape can result in a big, beautiful, fine art piece without necessitating traditional smiles directed at the lens.

A heavy winter fog blankets this coastal portrait.
24–70mm F2.8 lens, f/2.8 for 1/250 sec., ISO 100
Photo by The Image Is Found

alley hugging

Clothes are coordinated in a similar palette for this touching urban portrait of a father with his two little ones. Have the boy hug dad, and position the girl leaning against her father and looking at the camera. Use conversation or tell a story to get the kids' attention and natural expressions; then hit the shutter while talking. Want another fun lens grab? Arrange kids on either side of their smiling, kneeling dad, each planting a kiss on one of his cheeks.

tip When kids are small, get the grown-up down to their level for eye-to-eye portraits.

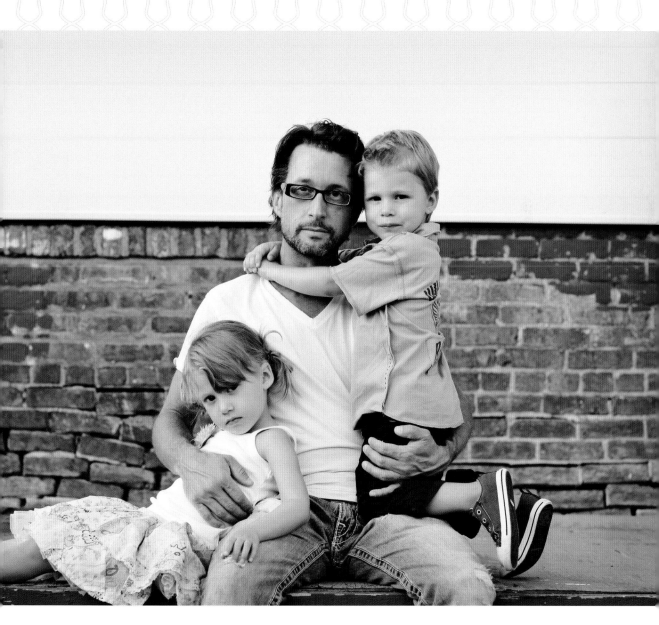

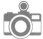 Shot outside in early evening in the shade of a building, this image has nice, even light.

85mm F1.2 lens, f/4.5 for 1/320 sec., ISO 200

Photo by Shannon Sewell

in arms

For this fabulous family huddle, ask the subjects to start by standing a couple of steps apart. Prompt the wife to step in and grab her husband; then instruct the father to pull his son close. On "Go," have everyone come together, and wait for just the right family interaction. The result: close encounters of a timeless nature. For another treasured portrait, zoom in tighter to frame just the child with his parents' hands and arms around him. An image of just the parents' faces makes for another beautiful portrait.

tip To eliminate empty space, direct families to get close together and cuddle up as though it's really cold outside.

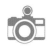

Taken by a beach in Oceanside, California, in the winter, this image features heavy, overcast light.
35mm F2 lens, f/2 for 1/250 sec., ISO 100
Photo by The Image Is Found

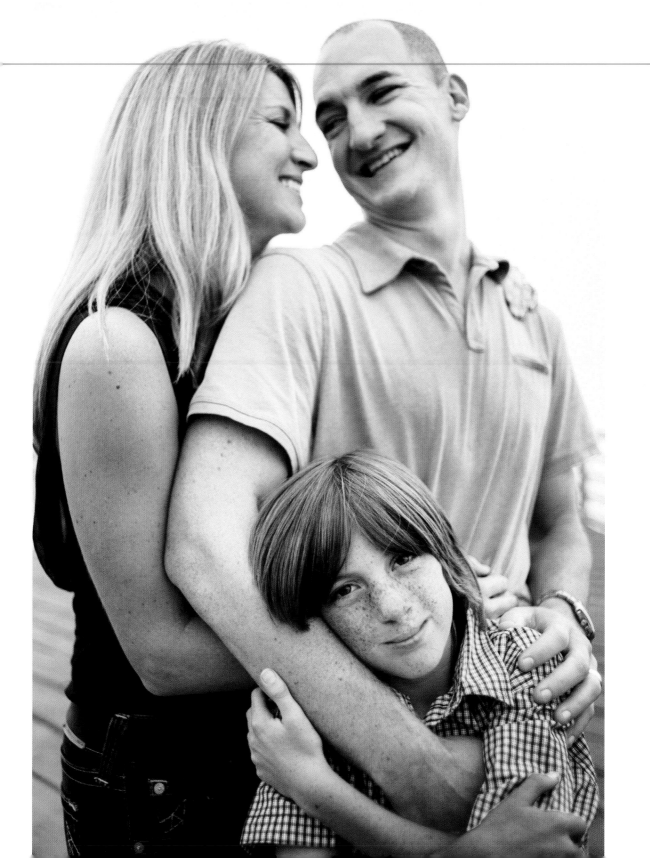

classic geometry

This delectable lifestyle pose is based on a classic triangle formation: positioning your subjects to create an apex with two sides. Simply place a child on one parent's shoulders, ask the family to move in close together, and let them interact naturally. Capturing loved ones slightly off-center behind wispy foreground grasses adds extra interest and depth. For a second portrait, move mom in closer, have everyone look at the camera, and crop in more tightly in a vertical composition.

.

tip The best way to capture a treasured moment is to set the scene. Choose a location and background that will look great no matter how much wiggling and tickling happens.

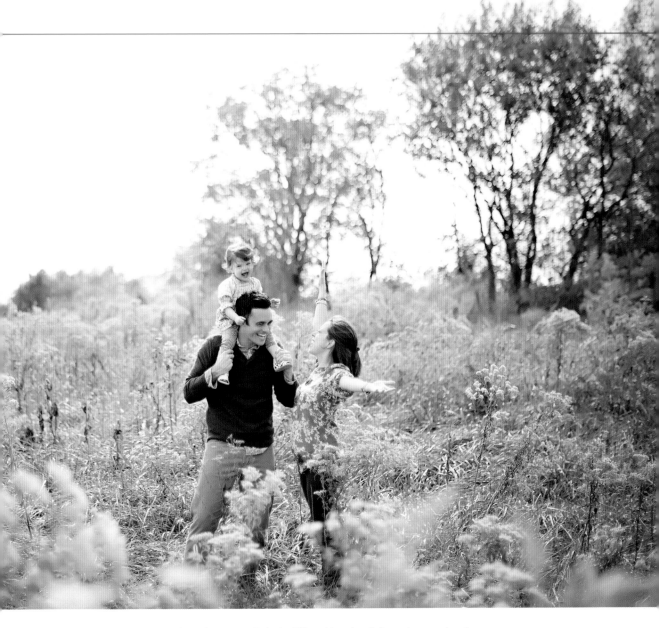

Soft, mid-morning light is diffused by clouds hovering overhead.

50mm F1.4 lens, f/1.4 for 1/5000 sec., ISO 200

Photo by Michelle Huesgen, Untamed Heart Photography

gone to the dogs

This atypical capture is a great first pose for warming up your subjects, assuming man's best friend is trained to behave around the baby. The low perspective and creative framing highlight how baby and dog can see eye to eye, at least for now. Years from now, the child will get a kick out of seeing how small he once was. For a quick second capture, ask mom and dad to hunker down, and capture their smiling faces lined up with the two shorter members of the family.

tip Always remember to integrate pets into family photographs. They are often the parents' first "child" and a very important member of the family.

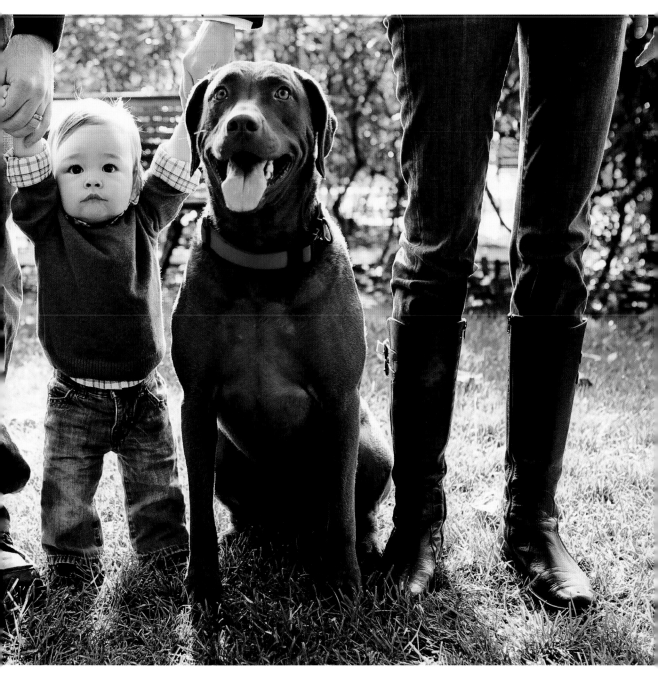

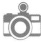 A low sun provides lovely backlighting on the subjects.
24–70mm lens, f/5.6 for 1/1000 sec., ISO 200
Photo by Milou + Olin

doorway
double shot

For a diptych like this one, remember that everyone loves mom, so make her the center of attention. Make sure hands are connected, and have dad place his arms around everyone with the prompt "Dad, protect your family by holding them tight." Shooting in front of a family's home ties the subjects to their environment, and the nostalgia it will inspire makes the portrait perfect for home display.

Dad can step out for a portrait of mom with each child for even more treasured images. Two of these pictures together make for a great display, whether printed as one portrait or as two framed photographs placed side by side.

tip To help your subjects feel comfortable and natural, have them pose less while you observe and interact more. Talk to them, ask questions about each family member, and get everyone relaxed, always making sure the camera is close by and ready for action.

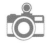

Slightly overcast skies help create this beautiful, dramatic scene, later converted into a black-and-white image.

50mm lens, f/3.5 for 1/400 sec., ISO 320

Photo by little nest portraits

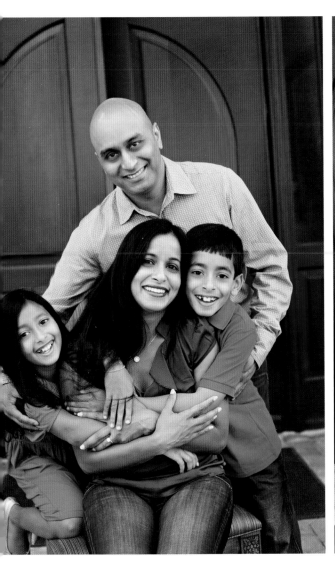

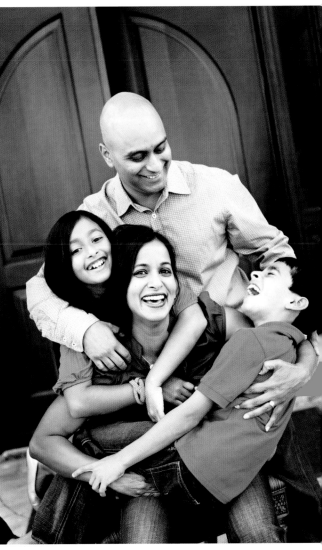

sitting pretty

Don't be afraid to take indoor furniture outside when the weather allows. Here, the photographer placed two classic Eames chairs in front of a white garage door for a less predictable setup. For a distinctly casual pose, layer parents in first, followed by the kids, with the youngest and smallest placed in front. Interact with your subjects to keep natural conversation flowing and ease them into a relaxed, comfortable stance. With small kids, talk about superheroes and make-believe. Modify this pose for additional kids or to feature kids exclusively.

tip You don't need stylish seats to pose a sitting family. Consider milk buckets, barrels, crates, ledges, or even hay bales.

Light on an overcast day is an appreciated treat—especially in wide-open spaces.
28–70mm F2.8 lens, f/7.1 for 1/200 sec., ISO 320
Photo by Lena Hyde Photography

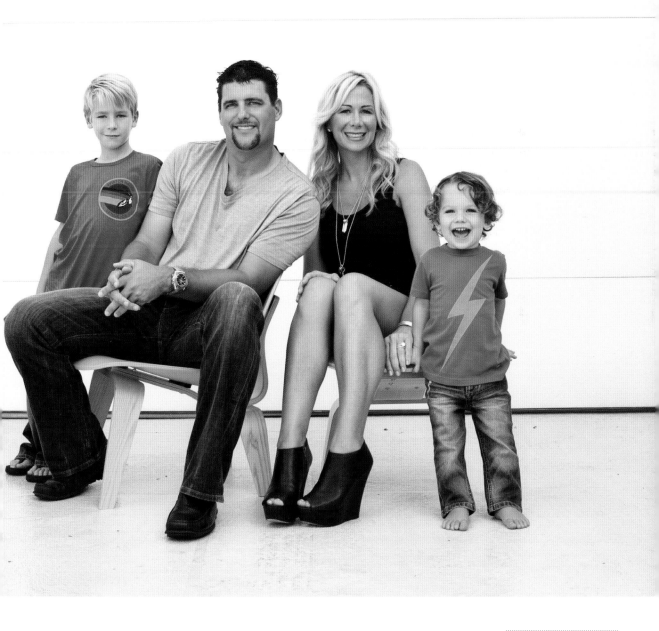

the great outdoors

Relaxed, informal portraits like this one are perfect for the end of a session when everyone is winding down. Beautifully branching trees in the background frame a family at a local orchard. Position the parents, and then have the kids lean against mom. For an important second portrait, have the kids stand out of the frame, and capture a picture of mom and dad only. After all, they may not have had a picture taken alone together for a long time. Images like this are a reminder of family and the love that brings everyone together in the first place.

tip When working with midday sun, make sure that light is evenly spread across everyone and that there are no harsh shadows or dappled lighting.

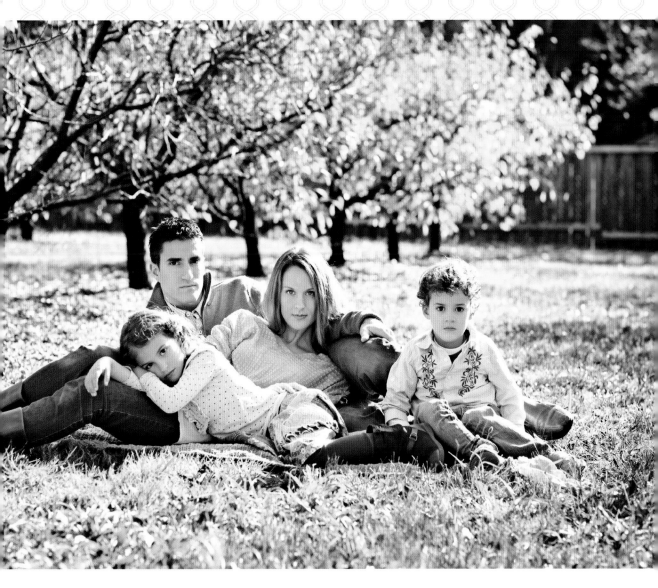

Midday sun provides backlight for these relaxed subjects on a blanket.

85mm F1.2 mm lens, f/4 for 1/250 sec., ISO 100

Photo by Shannon Sewell

busy bodies

Jumping and playing can be great ways to keep little ones occupied in a family photo. With more energy and interaction here than in traditional "sit and smile" portraits, this set of images provides an accurate representation of a family with active, young kids. Since kids near this age tend to run away if mom and dad let go, keep them engaged with plenty of shenanigans. For variety, have parents flip the kids upside down or place them on their shoulders. Keeping kids on a path can also corral them, at least temporarily. When subjects are on the move, be sure to use a fast shutter speed to capture the action without motion blur.

tip Having parents in the pictures at the beginning of a session not only helps capture family moments but sets the standard for how kids should behave during the shoot.

Shade from overhanging structures lets the fun heat up without direct, overhead sun.
135mm lens, f/2.2 for 1/500 sec., ISO 250
Photo by little nest portraits

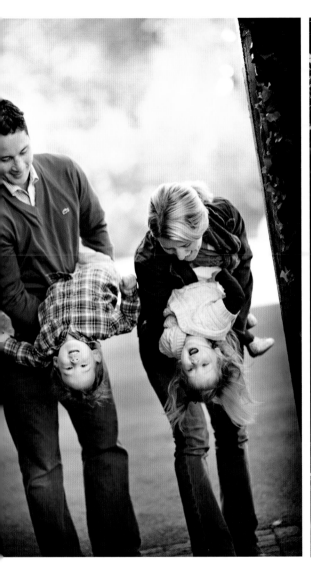

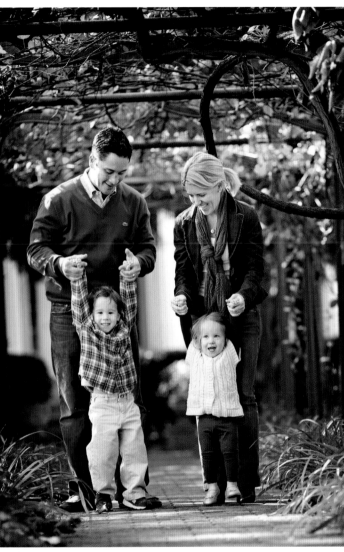

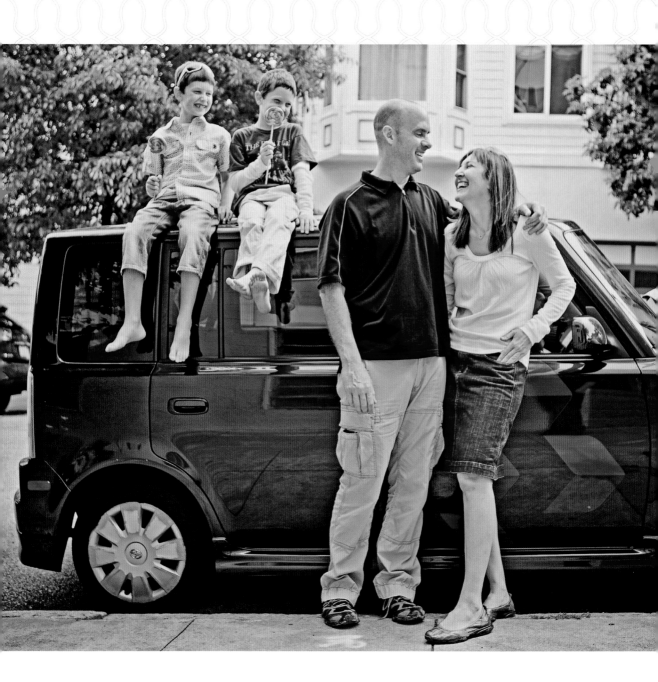

sweet ride

When the family has a fun car (like the boxy, purple rental shown here), work it into a shot or two. After all, one day these will be vintage modes of transportation! Carefully place kids on top of the car, get everyone laughing, and ply the kids with the promise of fun-colored sugar treats (with parents' permission, of course) for naturally happy expressions. Want to raise the fun to another level? Have the kids react to parents kissing with a "Look! Mom and Dad are going to kiss!"

t i p **Save confections for the end** of the shoot. Aside from the potential sticky mess, once that sugar rush hits, keeping kids calm is not an option.

The family faces a tall, white building that reflects the soft, midday light and ensures a sure shot.
24–70mm lens, f/2.8 for 1/250 sec., ISO 100
Photo by Milou + Olin

close to you

For a wonderful wide-angle portrait, have everyone pile on mom and dad while keeping the energy electric with jokes and silliness. Add a slight camera tilt to emphasize the sense of movement and fun. In this example, messy hair and great clothing layers provide great finishing touches. Want another grab? Put the kids on the parents' shoulders and snap a shot while mom and dad kiss.

tip Finger puppets, noisemakers, and squeaky toys (such as a rubber chicken) are portable and ready for any occasion where silliness is required.

 Natural light and open shade illuminate this fun-loving family.
24mm F1.4 lens, f/5.6 for 1/160 sec., ISO 400
Photo by Anna Kuperberg Photography

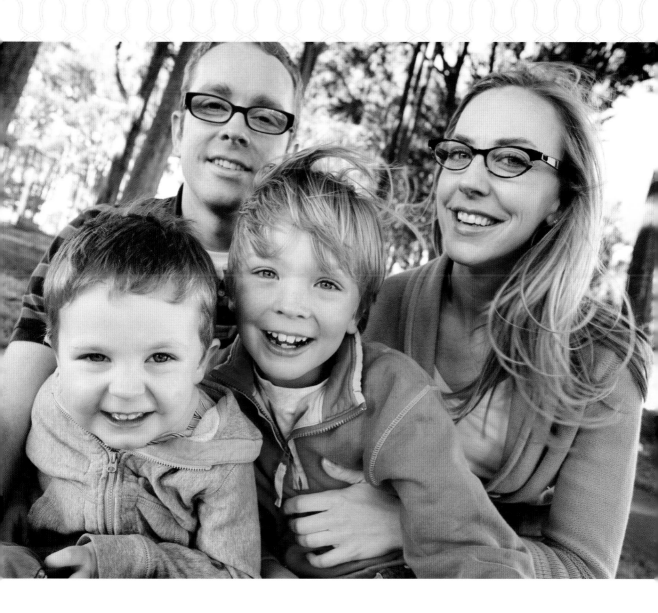

family tree

Photographing a family in a tree not only makes use of a natural prop but also frames the scene. Place dad and the kids in the tree first, each touching the person next to them; then have mom step in to complete the family. Shoot a little from the side for a more dynamic portrait. Here, the photographer makes the kids laugh. (Jumping up and down and acting silly are part of a portrait photographer's job description.) Grab another picture by zooming in tighter for a horizontal, half-body shot.

tip Notice how all the fingers and hands create connections among the family members—and how they don't look like awkward claws? Keeping hands engaged is flattering and makes use of otherwise aimless fingers, creating a more polished picture.

This family glows in beautiful backlighting, with a reflector bouncing light back onto their faces.
135mm lens, f/3.2 for 1/500 sec., ISO 250
Photo by little nest portraits

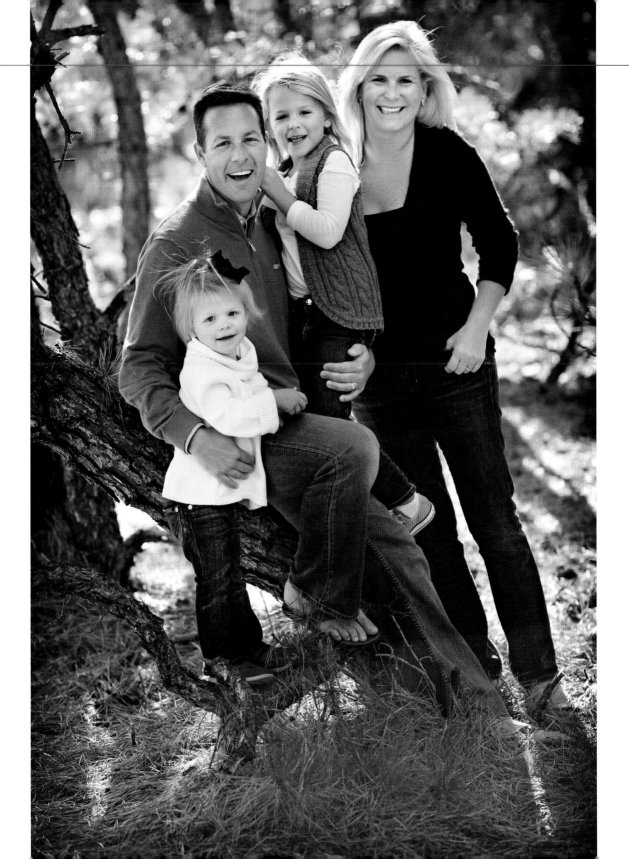

master suite

Everyone feels comfortable when reclining on the master bed. This is an especially useful pose when a family pooch is involved, as it helps to corral the pet. Stand on a bench or chair at the foot of the bed, and ask family members to position themselves with their heads toward the camera and with the baby (and dog, if applicable) in the middle. Ask them to be affectionate and gently tickle the baby to elicit giggles. For another intimate moment, get the baby on dad's chest, or capture everyone smiling and laughing cheek to cheek.

tip Be sure to open all curtains and window coverings in a client's home to decide which rooms will be best for shooting. If a dark room and consequently high ISO combine to create a grainy image, convert it to black and white.

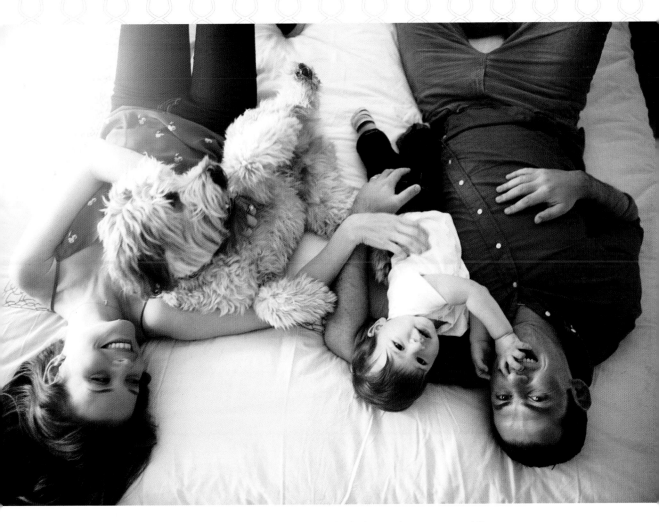

 To photograph in this dim room in which the windows were partially blocked by wood blinds and curtains, the photographer used a wide-open aperture and high ISO.

24–70mm lens, f/2.8 for 1/60 sec., ISO 1600

Photo by Tara Whitney

into the sunset

Just as sunset comes calling, ask dad to put his youngest on his shoulders while his other children stand on either side, holding his hands. Right before pressing the shutter on a striking silhouette like this one, ask the older kids to look up at their dad. For a different capture, grab an environmental shot from far away of the family walking either toward you or away from you while holding hands.

tip It takes practice to master the art of the silhouette. For a modern approach that retains more detail, such as in the image shown here, overexpose slightly—more so than for a classic silhouette.

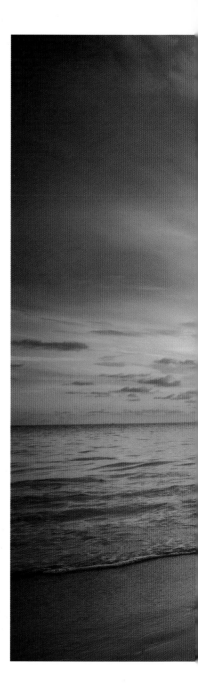

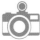 For this sunset shot on a Florida beach, the photographer metered for the sky, silhouetting the subjects while properly exposing the dramatic sky.

14–24mm F2.8 lens at 14mm, f/4 for 1/2000 sec., ISO 640

Photo by Lisa Roberts

accentuate the negative

Negative space can be beneficial, drawing the eye to subjects and evoking a more modern feel than when everyone is bunched together. Here, the family stands in the bottom half of the frame, centered to draw the eye around and downward, making them look very much a part of their environment. For variety, and especially when you have a great textured wall or backdrop available, try putting space between your family members. Want to grab a second capture? Ask family members to stretch out their arms and hold hands, and then—why not?— get everyone dancing.

tip Don't be afraid to act a little silly to get your family in the spirit of the shoot. To get this image, the photographer started dancing in front of a group of tourists to elicit smiles (from the family and the tourists).

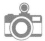 Late-morning light on a cloudy, bright day looks great playing off this wall. A bridge to the right partially blocked the sky, but light from above still brightened the scene.

24–70mm lens, f/2.8 for 1/100 sec., ISO 1000

Photo by Blue Lily Photography

prompt & promptability

Through specific suggestions and some prompting, subjects still show closeness and familial relationships without smiles aimed at the camera. For sessions in which the baby is crying, kids are in a bad mood because they're cold, and mom is exhausted, a split-second shift in direction can make all of the difference. Have dad lift the baby while mom connects with the other kids for a fun, important capture in which everyone is connected to one another and to the environment.

The camera's tilt can enhance the casual nature of the shot while keeping everyone physically connected. For a second image, have everyone face the camera, with dad still holding the baby, and go for a slightly tighter, zoomed-in, vertical shot showing their full bodies.

tip Always offer a snack and rest break halfway through a session. When kids get grouchy at other times, however, also take a five-minute break. Everyone will be able to jump back into the session with higher energy and renewed purpose.

This metropolitan family is sheltered from the harsh midday light by the adjacent brick building. Using shady spots is a great alternative to shooting in the late afternoon or evening, because children are happier earlier in the day or after a morning nap.

85mm lens, f/2.8 for 1/800 sec., ISO 400

Photo by little nest portraits

find their
happy place

Be sure to choose locations near and dear to a family for a comfortable, relaxed tone, whether a beach, field, or park. Here, this portrait captures the golf course behind the clients' home. After shooting the standard "everyone look at the camera" composition, have the family relax and interact organically for a natural, intimate moment. Using a long lens gives the subjects some distance from you and almost lets them forget they are being photographed.

tip Keeping subjects far from the background allows the focus to stay on the family while offering just a hint of the sumptuous surroundings.

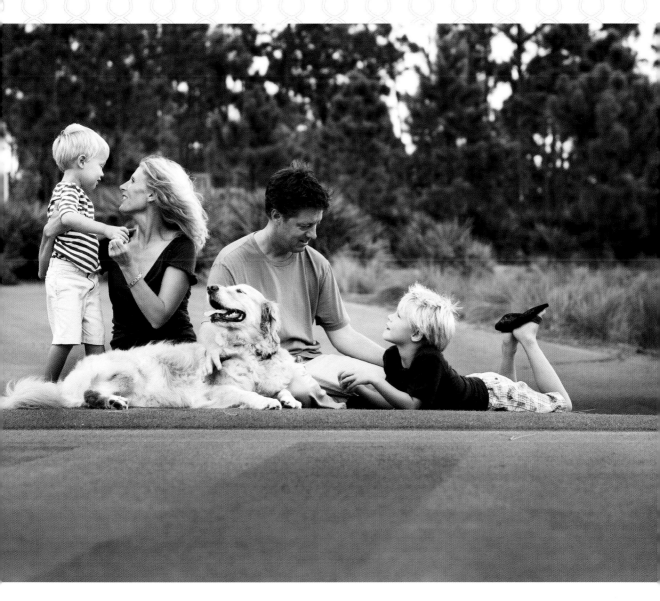

 The golden hours (the first hour after sunrise and the last hour before sunset) creates relaxed, beautiful light for this close family moment, finished with a warm black-and-white conversion.

100mm lens, f/5.6 for 1/320 sec., ISO 350

Photo by Lena Hyde Photography

center of
attention

The little girl is the princess of the family, so what better way to illustrate that dynamic than this stunning portrait where she is the focus? The image features a cute and original point of view, while the flattering black-and-white finish keeps potentially disparate clothing from stealing center stage. Frame the youngest within the other family members, and make sure everyone is sweetly touching her to draw the eye to the center of the composition. Want a different, delightful second shot? Have everyone look at the camera with heads together for a more traditional picture.

tip For an authentic family snuggle, tell parents to sit together first, and then have the children pile in. Ask them to pretend the camera isn't there, and watch as they sing songs, laugh, tickle, joke, hug, and kiss.

This setting is dark, but the baby's face is still well lit, keeping her the center of attention.
50mm lens, f/2.8 for 1/1000 sec., ISO 800
Photo by little nest portraits

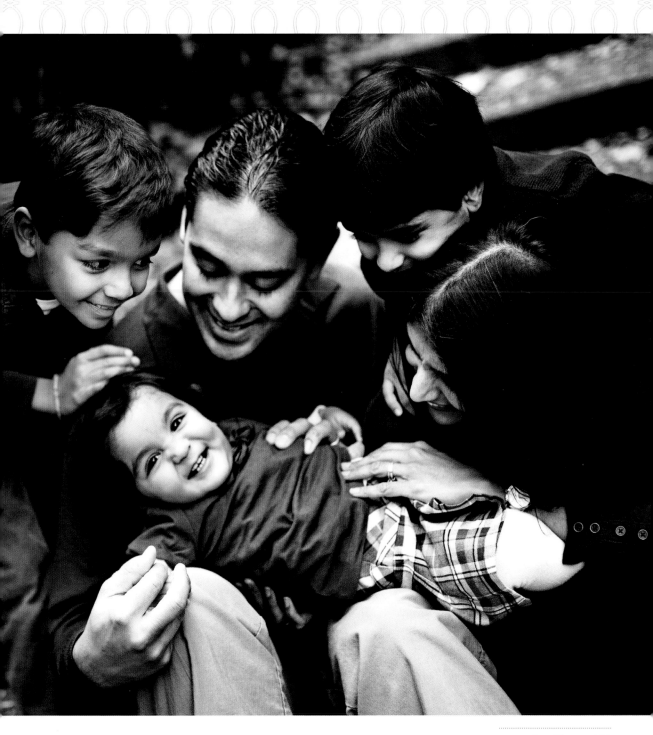

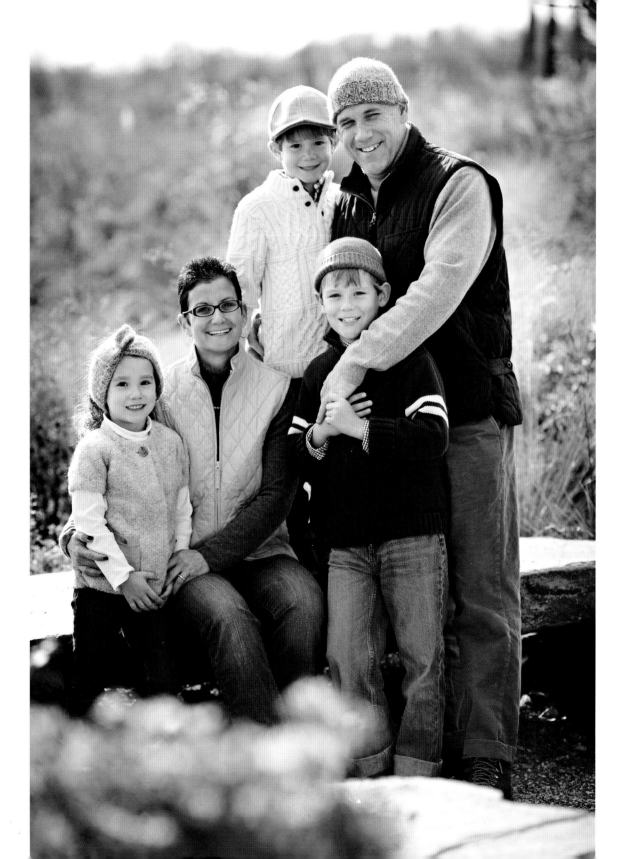

great grouping

This picture is complex and beautifully layered, framed in the front and back by flowers blurred with a shallow depth of field. Moving from seated members to standing also draws the eye from left to right, and from bottom to top, making this a connected, bonding image that you can capture in any environment. Pose everyone together so that kids are never behind the parents and everyone's faces are clearly visible. Pose mom, then kids, then dad, making sure everyone is physically connecting. For a second and third capture, shoot a tight close-up of only the gals in the family and then one of the guys.

tip

While capturing a family in a familiar outdoor setting, whether on their property or in a special place they like to hang out, be on the lookout for something new they might not have noticed before, like an interesting tree or rock outcropping.

Slightly overcast weather creates an image that is still well lit, but without shadows and squinting.
135mm lens, f/3.2 for 1/640 sec., ISO 250
Photo by little nest portraits

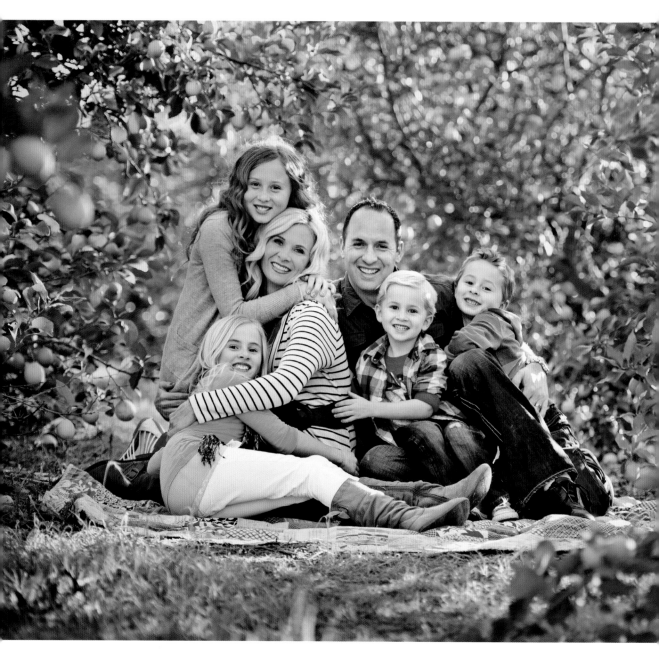

 This image is sidelit from behind the trees on the right without reflectors. To prevent light from coming through the leaves and thus spotting the parents' faces, a blanket was used in the trees.

70–200mm F2.8 lens at 112mm, f/3.2 for 1/200 sec., ISO 200

Photo by Blue Lily Photography

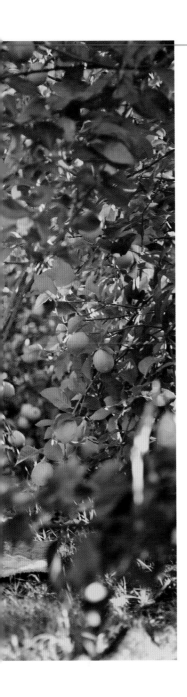

lean on me

Placing mom and dad in opposite directions frames this beautiful family and sets the stage for more casual and affectionate poses. Here, mom and dad recline away from each other but still overlap to remain together visually. The daughter snuggles with mom, while her brother remains alert and seated upright, showing their probable roles within the family ("mama's girl" and "the protector"). People are generally more relaxed when sitting, so layer everybody in; start with dad and mom, and then add everyone else, ensuring there are no awkward spaces. For two more beautiful captures, snap just the boys and then just the girls.

tip Use a quilt or blanket to protect clothing from dirty, wet, or leafy situations.

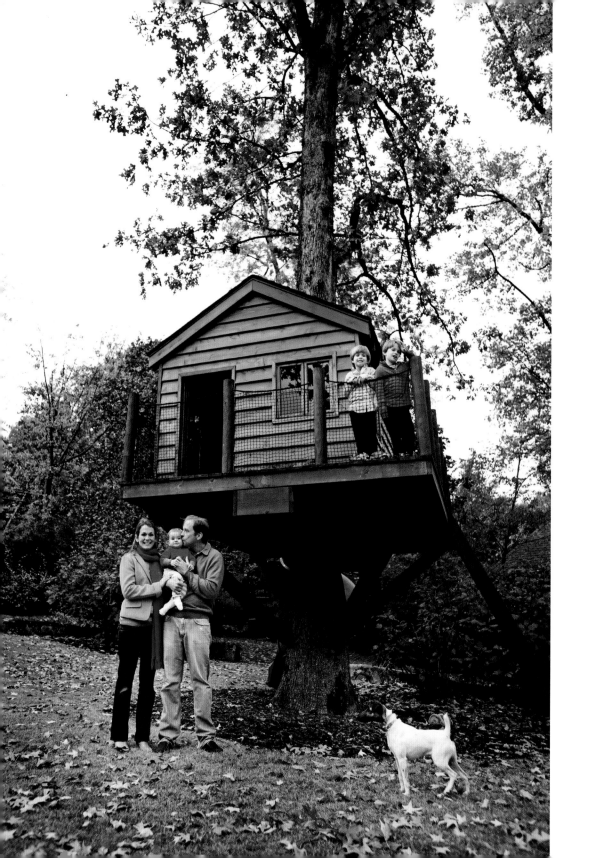

branching out in groups

Placing families in smaller subgroups often reveals their special, internal relationships while keeping the family together in one image. Here, the eye can travel around the portrait, as mom and dad share a sweet moment with the baby, and the older siblings enjoy their own company. Fido dutifully surveys the scene, holding down the right side of the composition. While parents may expect the shutter to snap once they are looking into the camera, also watch for moments when the family relaxes. For a second and third capture, grab an image of mom and dad only and then one of the kids on the ground cuddling with the baby.

tip Working with a tall structure? Have the kids sit with their legs hanging off of the side, and shoot up at them with a telephoto lens so that they appear higher than they are.

The winter light was soft and the day overcast for this session.
17–35mm F2.8 lens, f/4 for 1/200 sec., ISO 2200
Photo by Paul Johnson Photography

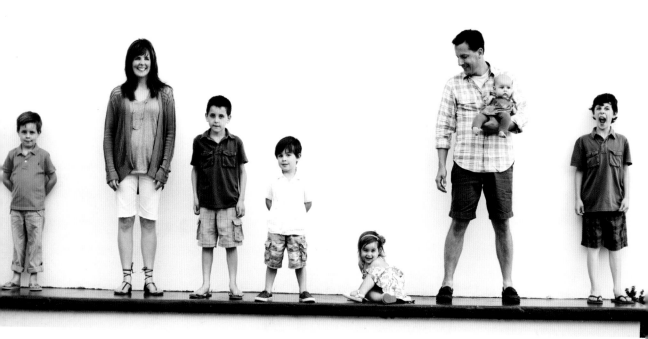

UNITED STATES POST OFFICE
Rosemary Beach, Florida

This portrait was photographed using only available
light, approximately thirty minutes before sunset.
85mm F1.4 lens, f/2.8 for 1/640 sec., ISO 200
Photo by Paul Johnson Photography

the lineup

Lineups are particularly useful for very large family groups. Here, the side of the town's post office and a ledge about eighteen inches off the ground create the perfect delivery system. For a classic lineup, ask everyone to stand in a straight line facing forward and give their best smiles. Immediately, each child's personality will emerge, from the ham to the sweet and sassy sister to the rebellious kiddo in flip-flops. Keep the energy high, laugh, and have a great time encouraging reactions from family members. For a second capture, squish everyone together to the left.

tip Grab pictures at locations that indicate the family's home or town, whether near the city's "Welcome to" sign or a post office that shares the town's name.

parting
thoughts

Photography is an ever-evolving learning experience. Portraiture, in particular, provides a challenge and opportunity for illuminating the shaded edges of another human being's life.

When performed with deft execution, a portrait is as honest a rendering as can be made of expression, mood, and the human condition. A photograph speaks to the beauty and mystery of humanity, distilling life into a singular, eternally preserved moment.

We hope you will take the ideas and concepts conveyed in this book and apply them in a way that speaks to you, the artist behind the lens.

Continue to hone your craft, and grow beyond concerns of f-stops and ISO, so that the emphasis of your creation is in the enjoyment of the art and the craft of storytelling.

> "A society grows great when old men plant trees whose shade they know they shall never sit in."
> —*Greek Proverb*

Most importantly, love what you do, and never lose sight of what sparked your interest in becoming a chronicler of small moments in time. The beauty you capture in one lifetime is part of a catalogue of memories that will be revisited for generations.

Photo by Anna Kuperberg

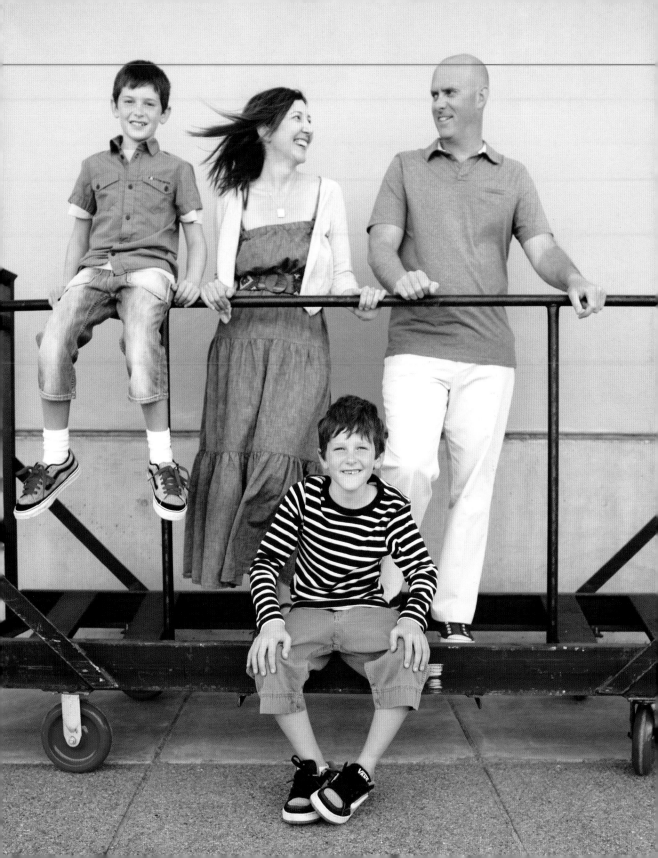

meet the photographers

Sandi Bradshaw of Sandi Bradshaw Photography has been a portrait, commercial, and fine art photographer since 2007, with her photography featured in magazines such as *InStyle* and published by a national greeting-card company. Her clientele includes families of professional athletes, actors, and celebrities. Sandi lives in Arizona with her husband, Paul, and children, Lane, Jaxon, Kellan, Rylan, and Suri. sandibradshaw.com (Photo by Sandi Bradshaw Photography)

When she's not shooting weddings and portraits all over the world, you can find Whitebox's **Sara Brennan-Harrell** hanging at her farmhouse in North Carolina with her husband, two kids, two dogs, two cats, and chickens. Sara's days are a mix of fun photo shoots, gardening, hanging laundry on the line, taking the kids to horseback-riding lessons, and lots and lots of photo editing. Someone once described her photography as a mix between *Vogue* magazine, apple pie, and Coca-Cola—elegant and timeless with a twist of fun and a pop of color. whitebox weddings.com (Photo by Whitebox Photo)

Rachel Devine of Rachel Devine Photography is a commercial child photographer, daily-life photo blogger, and coauthor of *Beyond Snapshots: How to Take That Fancy DSLR Camera Off "Auto" and Photograph Your Life Like a Pro* (Amphoto Books, 2012). She and her family are based in Melbourne, Australia, though she comes home often to America for work and play. racheldevine.com (Photo by Maile Wilson)

Mindy Harris is a portrait photographer known for her incredible ability to capture a family's essence and love—so much so that many photographers, both inside and outside the United States, have chosen her to document their own special relationships. Mindy spends time on both coasts all year, giving clients happy, beautiful, inspired images to treasure for years to come. pastelphotography.com (Photo by Kerianne Brown Photography)

~~Michelle Huesgen~~ of Untamed Heart Photography was raised in a small town in Missouri, where she spent many afternoons driving along the countryside admiring the colors and landscapes of the great outdoors and traipsing through backwoods creeks. Striving to bring those colors, landscapes, and imagination to her work, Michelle has been published in *Get Married Magazine*, *The Knot Magazine*, *St. Louis Bride Magazine*, and *Flourish Magazine*, and has provided catalogue work for Matilda Jane Clothing and The Good Ones clothing line. untamed heartphotography.com (Photo by Katie Saegar)

For the past fifteen years, **Lena Hyde** of Lena Hyde Photography has been transforming the way her clients view photography through her stunning philosophy of life as art and by creating memories of childhood that will be treasured for a lifetime. With advanced degrees in photography and art history, Lena is highly capable in both the technical and aesthetic possibilities of her craft. Frequently published and internationally exhibited, Lena speaks as a respected expert in the field of contemporary childhood photography and teaches sold-out national workshops several times per year. Lena is a cofounder of **Design Aglow**, the premier online source for design resources and success tools for professional photographers. lenahyde.com (Photo by Milou + Olin)

Paul Johnson Photography's **Paul** and **Mecheal Johnson** split time behind the camera capturing weddings, families, and individual portraiture. Though Paul was a photographer before he met his wife, Mecheal (he shot his first wedding at age 12), they have been shooting together since their first joint wedding in 1996. Their work has appeared in *Wedding Photography Unveiled* (Amphoto Books, 2009) as well as *Southern Weddings* and *Brides* magazines. Aside from shooting in and around their home base of Rosemary Beach, Florida, Paul and Mecheal travel often for their clients, whether to Scotland, Mexico, or the Bahamas. pauljohnsonphoto.com (Photo by Laura Johnson)

Nate and **Jaclyn Kaiser** are the four eyes behind The Image Is Found photography studio, which specializes in fun, authentic images of couples and families. The couple resides in San Diego with their two children, where they are always on the hunt for belly laughs and great stories to tell. theimageisfound.com (Photo by The Image Is Found)

Anna Kuperberg of Anna Kuperberg Photography is a wedding, family, and dog photographer based in San Francisco. Her work has appeared in *InStyle*, *People*, and *Martha Stewart Weddings* magazines. Anna's fine art photography has been exhibited nationwide, most recently in a solo show at the St. Louis Art Museum, and is in the permanent collections of the Philadelphia Art Museum, the St. Louis Art Museum, and the Portland Art Museum. kuperberg.com (Photo by John Riedy Photography)

Sheryll Lynne of Sheryll Lynne Photographers is a wedding and portrait photographer in Salt Lake City, Utah, and Louisville, Kentucky. She learned the basics of photography from her father (also a wedding photographer), the rest self-taught through classes, workshops, and books. While her style is continually evolving, she always strives to create fun, cheerful, and often quirky images for her clients. sheryll-lynne.com (Photo by Gianne Snow Photography)

Anna Mayer's honest, happy images capture the joy and magic of childhood, and her ability to connect with children and families, coupled with her smart business sense, has taken her photography from a part-time adventure to a full-time business in multiple cities across the United States. As mother to four active and adventurous children, she has honed her ability to see life through a child's eyes and a mother's heart. Her work continues to inspire families and fellow photographers alike. annamayer.com (Photo by Shannon Montez Photography)

Elizabeth Messina of Elizabeth Messina Photography is an award-winning photographer, author of *The Luminous Portrait* (Amphoto Books, 2012), and the happily married mother of three beautiful children. Her innate sense of style is reflected in her images, which have graced the pages of countless magazines. Elizabeth's work takes her around the world, but a piece of her heart always remains with her family. Their home in Southern California is full of laughter, laundry, kisses, and photographs . . . lots of photographs. elizabethmessina.com (Photo by Elizabeth Messina Photography)

Laura Novak of little nest portraits is known for her all-natural-light studio spaces. Pairing a sharp photographic eye with beautiful modern décor, Laura creates work that reflects her own simple-chic style. In 2007, Laura Novak was named by Eastman Kodak as one of two "Photographers to Watch" nationwide. She has since expanded her business to include more than a dozen employees and three locations. littlenestphoto.com (Photo by Jared Castaldi)

Lisa Roberts is an internationally award-winning photographer as well as an artist, dreamer, and lover of all people, animals, and small things with no words. Her work has been seen at *Boston Globe*'s "The Big Picture" and at NationalGeographic.com. lisarobertsphotography.net (Photo by Lisa Lucky Photography)

Shannon Sewell regularly works with renowned children's clothing companies, such as Urban Outfitters, and has been published in several online and print publications, including *InStyle*. She

found her perfect muse in her children, making a career of taking pictures of them and playing dress up. When they let her, Shannon is happy to dress up other peoples' kids and take pictures of them, too. Her mantra: "I believe the most important thing we can do is to love and be kind." shannonsewell.com (Photo by Kristy Behrs of Wreckless Creative)

As a fine art wedding photographer, **Jose Villa**'s approach applies fine art principles to the living, breathing, fast-moving phenomenon that is a wedding—with beautiful results. His goal is to craft vibrant, energetic, fine art images that are as unique as the people in them. With work appearing in publications such as *Martha Stewart Weddings*, *Elegant Bride*, *InStyle Weddings*, *Inside Weddings*, *Brides Magazine*, *Modern Bride*, *Cosmo Bride*, and *PDN*, Jose was named by *American Photo Magazine* as one of the top ten wedding photographers in the world in 2008 and one of the most influential photographers of the decade. josevilla.com (Photo by Elizabeth Messina Photography)

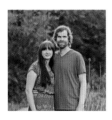

Wendy and **Tyler Whitacre** of Blue Lily Photography are professional portrait photographers currently on their third year-long tour of the world. Their work has been featured in the *New York Times* as well as on *Oprah* and *The Today Show*. They blog about their adventures, stories, and images, and have two kids whom they homeschool while on the road. bluelilyphotography.com (Photo by Blue Lily Photography)

More than just a job, photography is **Tara Whitney**'s "goose-bumps-tears-jump-up-and-down-on-her-bed-passion." Because life isn't flawless, she captures connections and real life as beautifully and authentically as possible. Entirely self-taught on Canon equipment, Tara has been photographing big and little people for the last thirteen years. She lives in Southern California, as close to the beach as possible, with her husband, four children, lots of music, and a backyard full of succulents. tarawhitney.com (Photo by Jack and Ruby Studios)

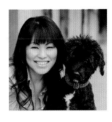

Milou + Olin's **Caroline Winata** is a classically trained artist with a free-spirited, bohemian, fashionably editorial, romantic style. With an adventurous and gorgeous mix and match of concepts—from bold and fun to feminine and beautiful—her photographs show an authentic interest in her clients as well as a love for the world and the people within it. In addition to her addictions to friends, fashion, big cocktail rings, and her award-winning Portuguese water dog, Milou, Caroline loves to obsess over design, happiness in obscure moments, randomly finding beautiful light, and meeting new people, preferably over decadent sashimi. milouandolin.com (Photo by Jill Carmel)

index